KARL BRIULLOV

Publishing Director : Paul ANDRÉ
Collaborator : Irina KHARITONOVA
Translators : Peter DEVIATKIN and Alla ZAGREBINA
Editors of the English text : Paul WILLIAMS
and Valery FATEYEV
Design : Sergei DIACHENKO
Computerization : Boris MALYSHEV

Printed by Sézanne - Bron FRANCE
for Parkstone Publishers
Copyright 1ˢᵗ term 1996
N°ISBN 185 995 298 4

KARL BRIULLOV

The Painter of Russian Romanticism

Introduction
by Galina Leontyeva

PARKSTONE AURORA

PARKSTONE PUBLISHERS, BOURNEMOUTH
AURORA ART PUBLISHERS, ST PETERSBURG

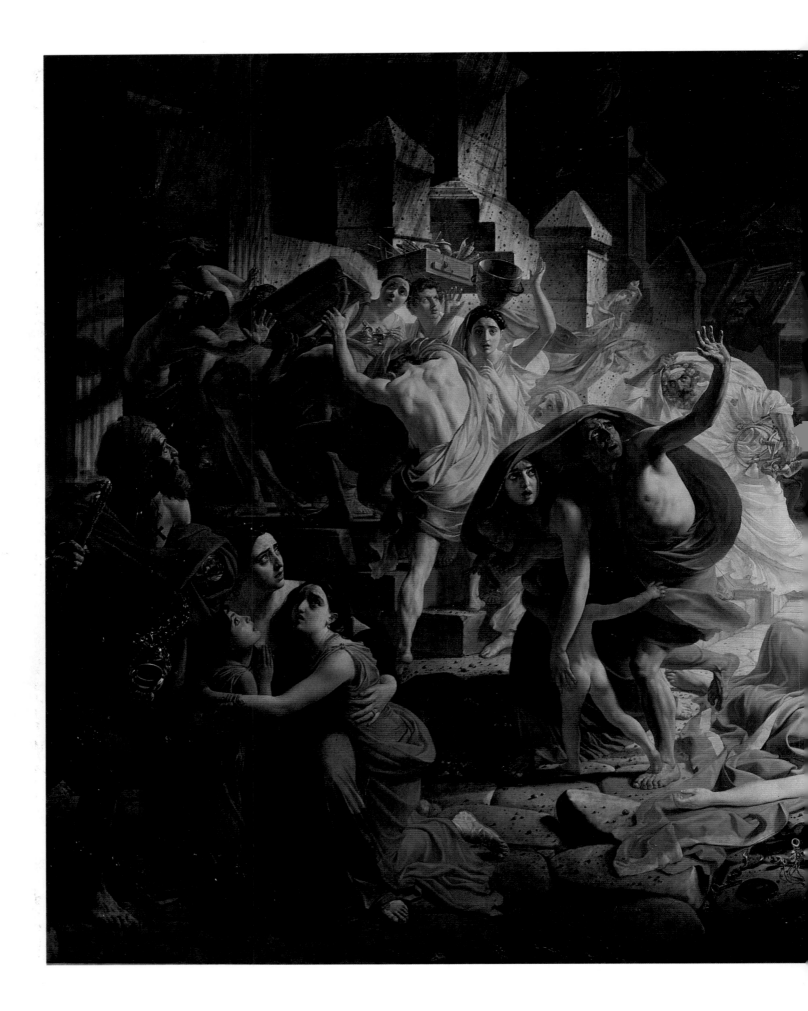

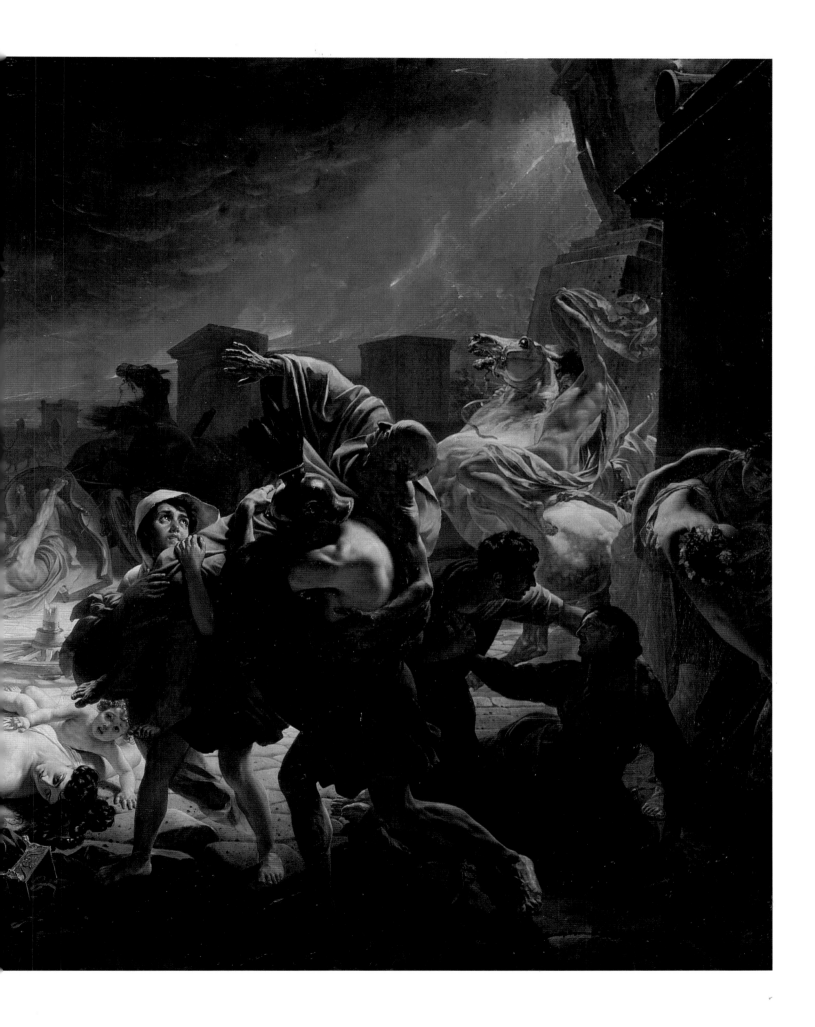

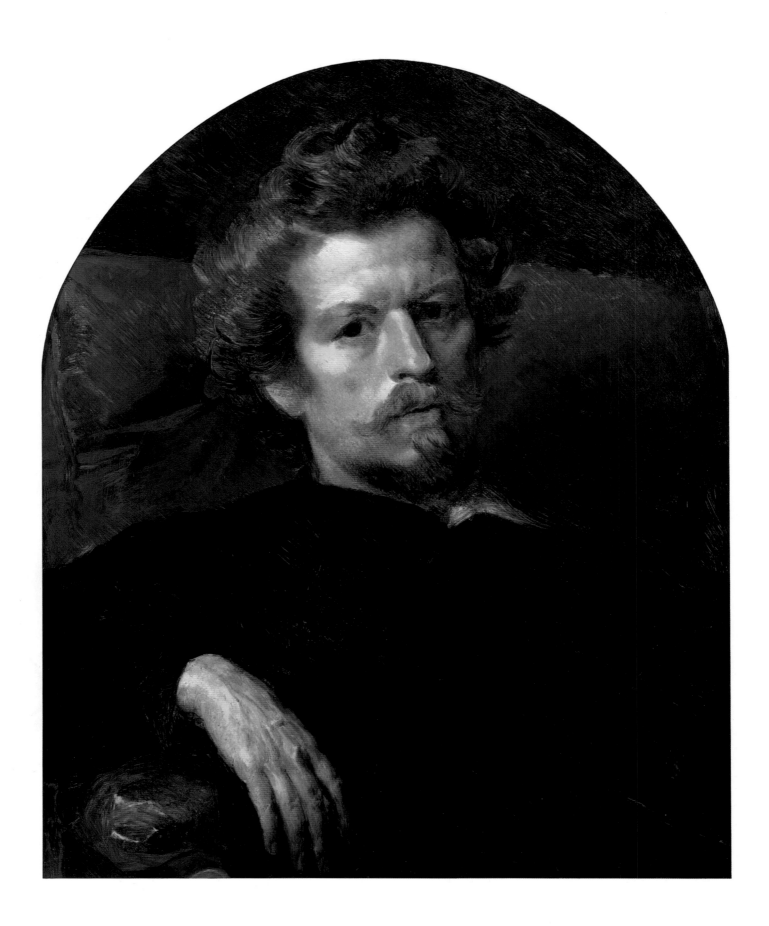

"Have you seen *The Last Day of Pompeii?*" For a time this question replaced the usual salutations exchanged by Romans when they met in *trattorias*, on the street or in cafés. Italian artists in unison agreed: "We all must learn from him." Even the most famous amongst them, Vincenzo Camuccini, upon seeing the enormous, brilliantly painted canvas, could not restrain himself from exclaiming: "Inflaming Colossus!"

The fame of this painting and its creator spread with remarkable speed throughout Italy. From Rome the painting was brought to Milan. The art lovers there expressed their feelings with still greater enthusiasm. In the theatre, neglecting the performers, the audience gave an ovation to the until recently unknown graduate of the St Petersburg Academy of Arts; a famous singer recited verses written in his honour and admiring fans lifted him in their arms and carried him through the streets of the city, accompanied by music, flowers and burning torches.

Briullov's popularity was growing. The renowned novelist Sir Walter Scott sat immobile before the painting for hours. The French ambassador to Rome, René de Chateaubriand, an aristocrat, writer and head of the European school of Romantic poetry, invited the Russian artist to a ball. Upon meeting him there, Chateaubriand told him: "I've just now said, 'You will see, Briullov won't come.' My heartfelt thanks for your coming."

The young artist's fame became so great that the Bolognese, Milanese and Florentine Academies of Arts elected him to membership. Hortense Bonaparte, a relative of the former French Emperor, expressed a desire to have him teach her drawing.

To what can we attribute his extraordinary triumph? Why would Italians, in particular, have such high praise for a painting by a foreigner? Why, later, when exhibited in St Petersburg did this work of art stir the best minds in Russia? To answer these questions we must look back, to that "northern Palmyra" thirty-three years earlier and travel along the road which led the creator of *The Last Day of Pompeii* to that height.

In the city of St Petersburg, capital of the Russian Empire, in a small house on Vasilyevsky Island, on 23 December 1799, a third son was born to the family of the retired Academician Pavel Brullo, and baptized Karl.

The Brullo family (when the brothers Karl and Alexander later travelled abroad they began to write their family name in the Russian manner, Briullov) had moved to Russia

long before. After the revocation of the Edict of Nantes, in fear of persecution, the Bruleleau (as they then were) family, together with other Protestants, fled France.

Karl Briullov's great-grandfather Georges began working, in 1773, as a modeller at the St Petersburg Imperial Porcelain Factory. His grandfather Ivan Brullo was a sculptor. Karl's father became known in St Petersburg as a virtuoso woodcarver and for his use of gold and silver pigments on glass. For some time he even enjoyed the status of professor at the Academy of Arts.

What can be found in Karl's childhood that would indicate the origins to the future famous personality? It may seem paradoxical but his ill health as a child played a role in his future profession. His illness and consequent inactive life contributed to his meditative and contemplative way of viewing the world.

The boy lived at home until the age of ten. The formation of Karl's character was undoubtedly influenced by that of his father who was an extraordinary individual. In the family's living room, on a central spot on the wall, hung his father's sword. Inscribed in gold on the blue enamel blade was the Masonic motto: "Stand for Truth." Though touching the sword was forbidden, the meaning of the motto, the ideas of "truth" and "justice", were often explained to the children. The elder Brullo was a mason, a member of a movement which at that time played a rather progressive role in the public and spiritual life of Russia.

Within the family there reigned a spirit of friendship, an exacting strictness and an emphasis on industriousness amounting almost to a cult. That the elder children would protect the younger was taken for granted. Perhaps because of his memories of the care he received from his elder brother Fiodor, Karl throughout his life took the side of the deprived and protected his pupils like a father.

The artist's own father was a just man but easily enraged. Once, for an offence that Karl later could not even recall, Pavel Brullo slapped him with such force that for the rest of his life he was nearly deaf in one ear. Karl inherited this volatile, emotional temperament from his father. He was intolerant of any contradicting opinions and yelled at his students; once, disappointed with his own painting *Bathsheba*, he flung his boot at it. By always giving free expression to his emotions he earned the right to be himself and to be independent. It was this particular quality that became the basis of Karl Briullov's personality.

While still living at home, Karl was instructed by his father. Every day his breakfast was kept back until he had

Angelo Toselli
THE ADMIRALTY

Part of the painting *Panorama of St Petersburg.* First quarter of the 19th century

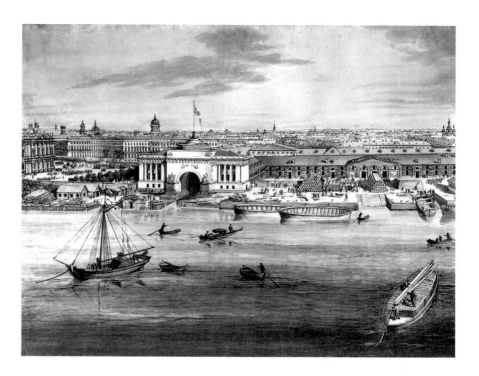

completed his lesson: to copy an engraving, or to draw a certain number of human figures or animals. Yet once, when his assignment had been fulfilled, he again took up his pencil and on the paper a closet, a table, a chair appeared. For the first time in his life, the future artist was not copying but drawing from his surroundings. Perhaps at that crucial moment he felt within himself a new power over things — the power to produce on paper a new reality, in the two-dimensional space of the picture.

There is one more episode from Briullov's childhood that we cannot neglect: the journey with his brother and sister across the city from Vasilyevsky Island to visit his grandfather at suburban Peski. For the first time Karl left the protected environment of his home and was exposed to the vibrant, exciting and possibly frightening world of the big city. Everywhere they drove, on Morskaya Street or Nevsky Prospekt, they encountered horses hauling huge blocks of granite, logs and building material. St Petersburg seemed then to be one vast construction site. Briullov's generation witnessed the finest architectural creations appearing in the Russian capital. In the first years of Tsar Alexander I's reign, a mood of general optimism arose, a lightening and uplifting new atmosphere. This atmosphere deeply affected the lives and the souls of Briullov and his contemporaries.

At the beginning of October 1809, Karl crossed for the first time the threshold of the majestic building on the Neva embankment whose façade bore the inscription "To the Liberal Arts". He had been admitted to the preparatory school of the Academy of Arts.

9

As the future artist began to study his craft and enjoy his life playing with his schoolmates, terrible events were brewing in the wider world.

Briullov had been born in the same year that saw Napoleon proclaim himself dictator of France. While rapidly conquering Europe, Bonaparte for some time maintained stable relations with Russia. In St Petersburg, Alexander I continued to receive dispatches from Napoleon addressed to "Monsieur, mon frère", while French troops were secretly concentrating on the Russian border. Then, on the night of 12 June 1812, an army numbering 600,000 men thrust into Russia. For half a year the war raged on the Russian soil, and it finally ended only on 19 March 1814, when Russian troops occupied Paris.

A sad paradox: the defeat of the French brought the victorious people still greater slavery. The Russian Tsar rejected the progressive changes he had espoused in his youth. Now his chief advisor was the Minister of War, Count Alexei Arakcheyev. The Count, an outright reactionary, was given sole authority to resolve all civil conflicts. Secret discontent with the situation inside the enormous Russian Empire was developing at all levels of society. In 1815 Alexander I became the head of the "Holy Alliance", which his contemporaries justifiably called "the union of the rulers against their peoples".

That year, 1815, was a changing point in the life of Karl Briullov. His childhood was over; he was now sixteen years old. He had successfully completed his course of study at the preparatory school; years of serious training at the Academy of Arts lay ahead. This period in Europe saw the development and emergence of many extraordinary talents. The Englishmen Byron and Shelley, the Austrian Schubert, the Pole Chopin, the Hungarian Liszt were all destined to be born in the inspiring period of social upheavals and revolutions; they grew to adulthood accompanied by the thunder of wars shaking the whole continent and matured in the years of cruel reaction. For Briullov's French contemporaries, Balzac and Delacroix, who developed in the light of Napoleon's glory, the Emperor's fall was a severe shock. Their art grew in the effort to overcome the national tragedy and in the painful re-assessment of values that followed. For the Russians, Pushkin and Briullov, Gogol and Glinka, Alexander Ivanov and Yevgeny Baratynsky, the victory over the French tyrant became, on the contrary, a powerful resource, feeding their freedom-loving aspirations.

After six years of study at the Academy, Briullov had become a master of the classical system, which at that time was being

Maxim Vorobyov
THE NEVA EMBANKMENT NEAR THE ACADEMY OF ARTS
1835

adopted by all the academies of Europe. His composition *The Genius of Art* is eloquent proof of that. Never again, perhaps, would Briullov create anything so purely classical in style. Soon images from real life began to penetrate into his work. The artist tried to combine on one canvas both elevated and everyday images in, say, the painting *Narcissus*, commissioned by the Academy in 1819. On first inspection that work appears to completely obey the classical canon: the ideally beautiful Narcissus, with his posture and bodily proportions reminiscent of the ancient sculpture known as the *Dying Gaul*. Clearly expressed are the conventional planes: foreground, middle and background. The trees to the left and right are like theatrical *coulisses*. Yet, at the same time, various nuances set this painting apart from the usual academic productions. While working on *Narcissus*, Briullov often visited the Stroganov Garden, situated around the Count Stroganovs' suburban house situated on the banks of the Chornaya (Black) River. Near one path in the garden an ancient sarcophagus stood, and at the descent to the water there was a statue of Neptune. The main entrance was decorated with copies of classical statues — the *Farnese Hercules* and *Flora*. In the atmosphere of that garden it was easier to imagine the beautiful youth Narcissus, the son of the river god Cephisus and the nymph Liriope, described in Ovid's

11

Metamorphoses. One hot day, Narcissus, bending down to drink from a stream, caught sight of his own reflection and fell in love with himself. For that, the gods transformed him into a flower.

Compared to *The Genius of Art*, *Narcissus* cannot be termed an example of purely classical art. Briullov interpreted the old legend, bringing out the moral idea that when an

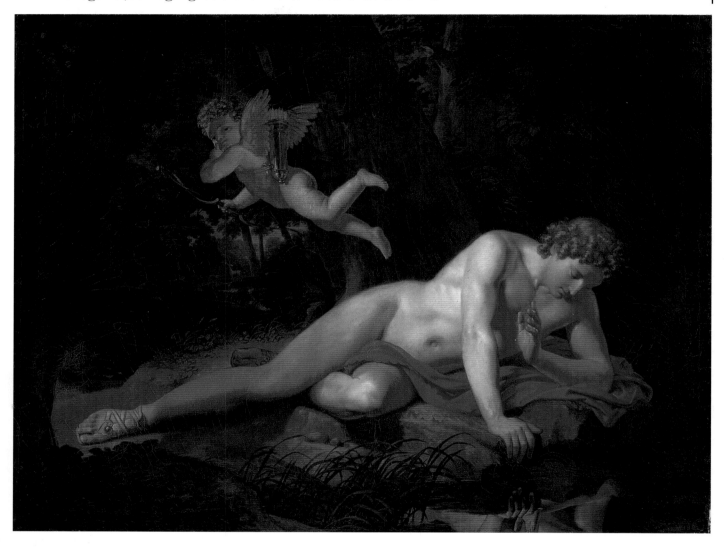

individual is in love with himself he has lost life's highest value — love of people.

Elements from nature appear in the background of *Narcissus*: the youth's glowing body is wrapped in soft twilight; the air seems warm and distinctly southern, and through the dark green foliage the rosy sky can be seen, tinted by the setting sun.

Briullov's graduation work *The Appearance of Three Angels to Abraham by the Oak of Mamre* was more traditional. However hard the artist strove to alter the composition, the images or the colour range he used, the picture remained almost totally within the strict classical precepts.

Karl Briullov
NARCISSUS
1819
Oil on canvas. 162 x 209.5 cm
Russian Museum, St Petersburg

Nevertheless, when compared to the work of his fellows, Briullov's painting stood out for its mastery of execution. Graduation day arrived, when in the Academy's main hall the students received certificates and medals. Briullov was awarded the Large Gold Medal, a first-class certificate "with a sword" and an assortment of medals for his many accomplishments during twelve years of study at the Academy.

In his years at the Academy this rather small, good-looking youth with an unusual talent and fiercely independent character had learned much. He differed markedly from the usual run of students. Even his older classmates considered him a "little wonder", carrying him back and forth to the dining hall on their shoulders. His main teacher, Professor Ivanov, said that from his early years at the Academy everyone had expected extraordinary things from Karl. He read an unusual amount for his age, and spoke German and French fluently. Karl acquired artistic skills so rapidly that he was the only student permitted to pass from monotonous copying to the class of plaster modelling before the end of the semester and he was generally given more liberties than his fellows. Karl was even given permission, during his third year at the Academy, to work not only from plaster casts and life models but also to create his own composition. Therefore it is no surprise that he achieved a position of leadership and authority amongst his fellow students.

When his course of study was finished, Briullov received an offer to stay on at the Academy, with a scholarship, for three more years. He agreed, but only under the condition that his teacher would be Professor Ugriumov. The President Alexei Olenin insisted on another supervisor, Inspector Yermolayev, who was unacceptable to Briullov.

Briullov would not agree. Organizing a private party and inviting his closest friends, Briullov raised a toast to the health of their former teacher, while openly declaring that Olenin was anathema to him. Everyone present readily agreed, as the Academy President was not greatly loved. This demonstration, rather than revealing a childish side to Briullov's character, showed his vital need for independence. And time did eventually prove him correct: without independence there is no real art.

Although Briullov loved his family, he had no desire to return to living under his father's strict eye. Fortunately his brother Alexander, also an Academy graduate (from the Department of Architecture), was invited to take part in the construction of St Isaac's Cathedral. The Briullov brothers began to live together in a small wooden studio, leading a Spartan existence.

13

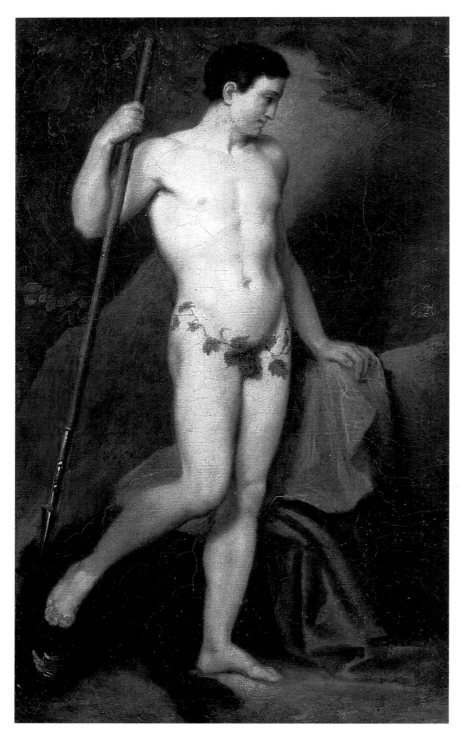

With his brother away each day at the construction site, Karl passed a rather lonely two years. This period marked a kind of pause in his creative life — a time of meditation and re-evaluation. He was no longer attracted to the historical genre, although it was considered the most important within the walls of the Academy. He found it tiresome to continually repeat work from the same models and felt within himself a desire to portray the faces around him. But how to do it? He did not want to reproduce the styles of the famous portrait painters Rokotov, Levitsky or Borovikovsky. Briullov

Karl Briullov
NAKED YOUTH WITH A SPEAR (MODEL)
1810s. Study
Oil on canvas. 56 x 34 cm
Russian Museum, St Petersburg

Orest Kiprensky
PORTRAIT OF YEVGRAF DAVYDOV,
COLONEL OF THE LIFE-GUARDS
1809

was already drawn to the new trend in literature: Romanticism. He was attracted to the idea that the unique character of the human being is the centre of art. He alone, among St Petersburg artists, with the possible exception of Orest Kiprensky (who was in Italy at the time), was attracted by Romanticism. Briullov was familiar with Kiprensky's work. No wonder, then, that the first portraits by the young artist reminded observers of the already famous Kiprensky.

Karl Briullov began to paint portraits of the founders of the Society for the Encouragement of Artists: Alexei Dmitriyev-Mamonov, Piotr Kikin, his wife and daughter, Karl's own grandmother, the Ramazanovs (an acting couple) and even their household cook. When dining at the Ramazanovs during Shrovetide, Briullov so liked the pancakes he was served that he called for the "author". He depicted the cook as he saw her, aproned, hair dishevelled and kitchen utensils in hand.

At this juncture Briullov's skill as a portraitist was definitely growing. But he had also to think of his daily bread. To live in St Petersburg as a free artist, without receiving constant commissions, was well nigh impossible. A career as a fashionable portrait painter was not for him. At that critical moment, mercifully, Providence intervened.

In 1821, the year of Briullov's graduation, the Society for the Encouragement of Artists was established in St Petersburg. To join the society one needed nothing but good will and the ability to make a sizable monetary donation. As a rule members came from the educated aristocracy. Historically, the Society, quite naturally, developed in competition with the Academy, finally finding itself in outright opposition. The Society for the Encouragement of Artists supported artists unaccepted by the Academy, organized exhibitions and sales of their work, published textbooks and subsidized the most talented young artists by sending them abroad to continue their training. The first to be accorded such an honour were Karl and Alexander Briullov. They received a four-year scholarship to study in Italy.

Their departure was scheduled for 16 August 1822. Nobody knew that Alexander Briullov's stay in Europe would stretch to eight years while his younger brother Karl would remain abroad for thirteen. Karl was not destined to see his mother, father or his younger brothers Ivan and Pavel ever again.

They travelled by way of Riga, the small towns of Prussia, and finally Berlin to Munich. Because Karl became ill, they were detained in Munich until April 1823. They began to work at the Munich Academy, Karl eventually painting portraits of some influential citizens of the Bavarian capital: the Minister of Finance, the Minister for Home Affairs and

Karl Briullov
THE GENIUS OF ART
1817–20
Black and white chalks, charcoal
and pastel on paper. 65.2 x 62.2 cm
Russian Museum, St Petersburg

their respective families. Evidently those two years as a free portrait painter had not been spent in vain — otherwise it is inconceivable that a young unknown foreigner could acquire such lofty commissions.

The brothers continued to study in the midst of their journey. Yet their lessons, rather than originating at the Academy, came from life itself, and from new, romantic art forms, unusual and even somewhat frightening. At first they admired only the arts of classical antiquity and the great Raphael. The works of Dürer, Correggio, Holbein and the Italian primitives seemed to them somehow remote and incomprehensible. Karl expressed great criticism of the

Fiodor Matveyev
A VIEW IN ROME. THE COLOSSEUM
1816

contemporary German Romantic school. Nevertheless, the young Russian artists arrived at the conclusion that they could forge new paths in art that did not derive from either the arts of antiquity or from Raphael.

At that time groups of artists were already emerging in Western Europe who questioned whether the classical ideals were indeed flawless. That was also the first serious conclusion Briullov made during his journey, though it took many years of difficult labour to put it into practice.

At the onset of spring, the Briullov brothers continued on their journey to Italy. In Venice they could not help but pause for some time. The city with its numerous domes

17

and towers seemed an enchanted architectural mirage while its quiet streets were paved with water. In the museums of Venice they were able, for the first time, to really appreciate the works of Tintoretto, Veronese and, especially, Titian. Departing from Venice they travelled to Florence. There they were not too tired to appreciate the creations of Raphael, Titian and Leonardo da Vinci, but they remained almost indifferent to Michelangelo. His work struck them as outrageous, too energetic and his figures too removed from the classical idea of beauty.

On 2 May 1823, they arrived in Rome, the Eternal City. At first they made no attempt to work, preferring to spend their time walking the streets in admiration. Italy in the nineteenth century had become a sort of mecca for many European and Russian writers and artists.

Following the publication of Madame de Staël's novel *Corinne or Italy*, veneration of that country had turned into a veritable cult. The poet Alphonse de Lamartine undertook a pilgrimage to trace the places mentioned in the novel. For the French Romanticists, Musset, Hugo, George Sand and Balzac, Italy became a favourite setting for their works. In his declining years Goethe once exclaimed: "If I remember what I felt in Rome! No, never have I been as happy!" Italian nature in itself favours creative work — seemingly the sun loves the land more and is more generous to the people there. For foreign artists the art of Italy was the greatest school. "In Rome, it is a shame to create something ordinary," Karl wrote, "and therefore every artist, wishing to improve his work, strictly analyzes it, looking for resemblances with nature..." It was to this end that Karl Briullov devoted much of his time and strength during his first years in Italy. Upon seeing creations of classical antiquity, that he had hitherto known only from plaster copies, he was overwhelmed. Admiring the translucency of the marble, he wrote: "Apollo doesn't seem to be made of stone or too far removed from nature — no, he just seems to be a better man!"[1]

It must be noted that the circle of artists admired by Briullov had begun to broaden. Now his interest in Rubens and Rembrandt was aroused, but Raphael remained his ideal. After many hours spent closely examining Raphael's canvas *The Assumption of Christ*, he noticed with amazement that although the great master had placed the most important figures, Christ and Moses, in the background, they were larger than the lesser characters depicted in the foreground. Briullov found the answer to this puzzle; Raphael was striving to "draw the attention of the viewer to the most important persons."[2] This was a great revela-

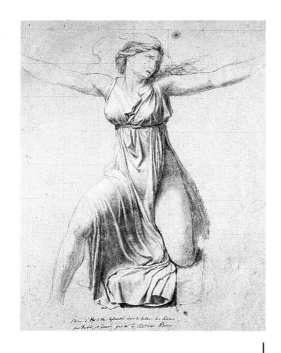

Jacques Louis David
GERSILLA
Study for the painting
The Sabine Women of 1795–99

[1] *Masters of Art on Art*, Moscow, 1969, vol. 6, p. 263 (in Russian).
[2] *Ibid*., p. 260.

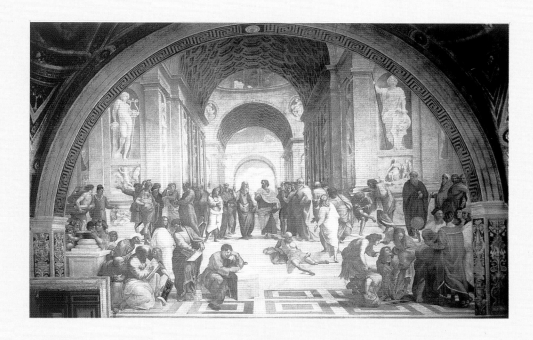

Raphael
THE SCHOOL OF ATHENS
1510

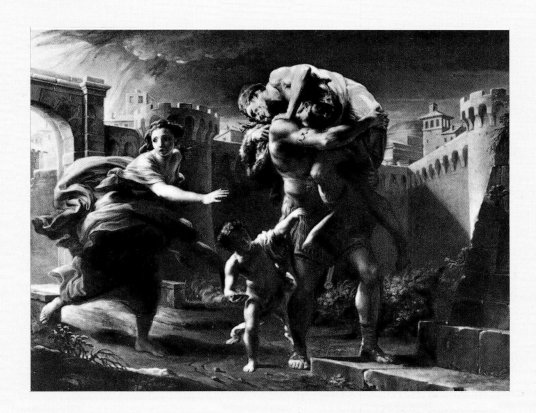

Pompeo Girolamo Batoni
THE FLIGHT FROM TROY
C. 1750

tion for the young artist. Did it mean that a great difference existed between the truth of reality and the truth of art? Did it mean that an artist, in order to express his ideas, could allow himself to neglect technical discrepancies? To penetrate the depths of the methods used by great Italian, Briullov in 1825 began to copy Raphael's enormous, multi-figured work *The School of Athens*. No other artist had ever risked such an endeavour. Briullov found himself dwarfed by the work's grandiose conception, its simplicity combined with grandeur and the extraordinary quality of the light. In his opinion, "all life was to be found in the work, including composition, communication, conversation, movement, expression and the contradictions of characters." It took Briullov four years to complete his copy of *The School of Athens*. During this time he conducted a private spiritual dialogue with the great Raphael and at last came to understand the inner structure of the work. Afterwards Briullov confessed that he had only dared to paint his *Pompeii* such an enormous size because he had trained at the school of *The School of Athens*.

Even then, in his youth, he habitually worked on several projects at a time. While making the Raphael copy, he also worked on preliminary sketches and studies of ancient history and biblical mythology. Only two of these works ever came near completion: *Bathsheba* and *Erminia with the Shepherds* — based on Torquato Tasso's famous poem *Jerusalem Delivered*.

Briullov immersed himself in the rhythm of Italian existence. Like a monk released from a monastery he wanted to grasp all of life at once. He wanted to stroll through Rome, drawing materials in hand, to travel throughout the country, to sit drinking wine at the Café Greco — where artists and poets gathered to converse or argue. He wanted to enjoy the creations of the great masters, he wanted to love and to work. During the first year of his stay in Italy he primarily painted portraits and genre scenes featuring simple Italian people. A visitor to his studio could see, standing on his easel, his small-scale composition *Italian Morning*. No-one, it seems, could dislike this portrait of a young girl washing herself in the streams of a fountain. The sun, coming from the rear and lighting the rippling water, is reflected on the young girl's face and bosom thereby creating a most difficult task for the artist. But Briullov solved this problem brilliantly. Some elements of ancient art are also still discernible: the range of colours, the conventional background, all done in a traditional, classical manner. The artist adhered to the contemporary concepts of grace and elegance. The painting *Italian*

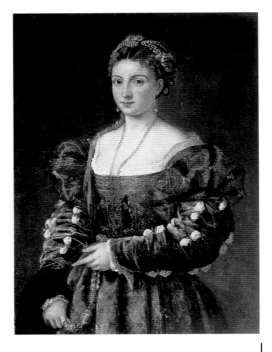

Titian
A BEAUTY
1536

Anthony van Dyck
SELF-PORTRAIT
Late 1620s – early 1630s

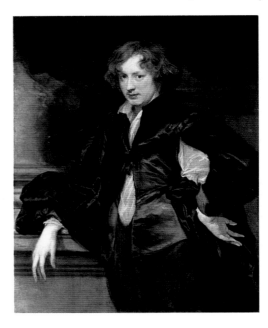

Morning was presented by the Society for the Encouragement of Artists to the Russian Tsar Nicholas I, who subsequently commissioned a further painting, to be similar and "pleasing to the eye". Briullov, attempting to fulfil the Tsar's wish, created a new work, *Evening*, in which a young woman, standing by a window and holding a lamp, is bidding farewell to her lover. But comparing the *Morning* and the *Evening* Briullov concluded that they did not match. The latter is simply a genre painting while *Morning* shows not only the

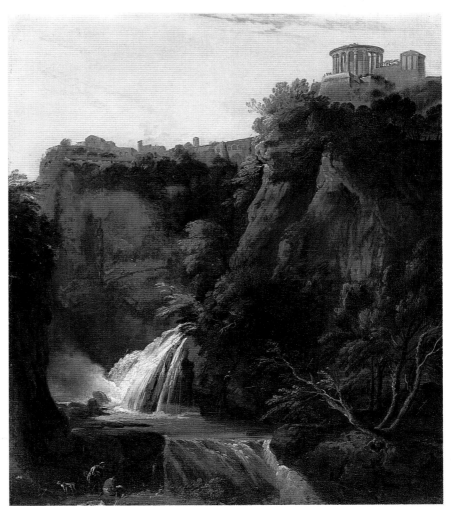

start of a new day but the dawn of a human life. The painter was strict and demanding on himself. Undoubtedly *Evening* and another painting of the same cycle, *Young Girl Gathering Grapes in the Neighbourhood of Naples*, would have met the Tsar's request but Briullov felt them to be trite and superfluous. The model depicted in *Young Girl Gathering Grapes* reminded him more of a dancing maenad dressed in a modern costume than a true representative of the people. Yet the theme itself — a vintage season — inspired his next endeavour, *Italian Midday*. To give life to his mental image of a new painting he had first to find a new model.

Sylvester Schedrin
WATERFALL AT TIVOLI
Between 1821 and 1823

21

And he found her. He had never had such a model before. She was a small, robust woman, the proportions of her figure and features of her face hardly suggesting the accepted classical standards. Her mature beauty, her shining, dark eyes widely set apart and her vitality totally conquered him. Briullov was then thirty years of age and in the period of maturity as an artist.

That Italian woman, gathering juicy fruit, radiates the joy of life. The rays of the midday sun, penetrating the green leaves, caress her face, gleaming in the whites of her eyes and her golden earrings, and also paint her white blouse

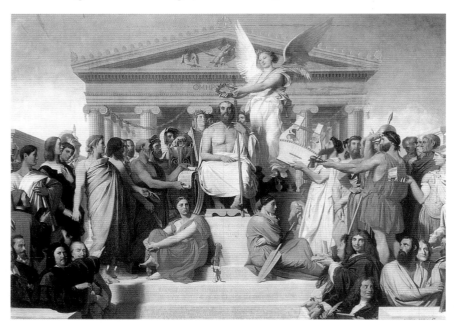

with a multitude of colours. She herself, like the grapes she is gathering, is a product of the earth and the sun. It is the height of the day, the height of a human life. This symbolic and harmonious fusion is the essence of Briullov's new concept. For the first time he had found a type of national, folk beauty, to which he would repeatedly return — in *Bathsheba*, in the sketch *Genseric's Invasion of Rome* and in many of the women's faces in *The Last Day of Pompeii*.

In St Petersburg, in contrast to his painting *Italian Morning*, *Italian Midday* aroused unanimous indignation. The Society for the Encouragement of Artists severely reprimanded him: "... the aim of any artist should be to portray a model with gracious proportions whereas your model could not be considered gracious since she belongs to lower class."[1]

Karl stood alone against all other opinions, yet he held to his position. He was so sure of being right that he answered the Society categorically: "In a painting, by using colour, light and perspective, an artist becomes closer to nature and therefore has the right to sometimes reject the

Jean Auguste Dominique Ingres
THE APOTHEOSIS OF HOMER
1827

[1] *The Briullov Family Archives in the Possession of V. A. Briullov*, St Petersburg, 1900, p. 102 (in Russian).

Jacques Louis David
THE OATH OF THE HORATII
1784

conventional forms of beauty." He went on to forthrightly declare: "... regulated forms of beauty make everyone alike,"[1] — in other words, if an artist blindly submits to the classical canon it will lead to homogeneity in paintings.

The creation of *Italian Midday* was the culmination of his many years of searching, his discoveries and his achievements. The continual necessity to justify himself, the feeling of dependence on an alien will and taste, asking and waiting for funds from the Society for the Encouragement of Artists oppressed Briullov. His scholarship for 1828 was delayed, not arriving until late May 1829. Briullov received it as he

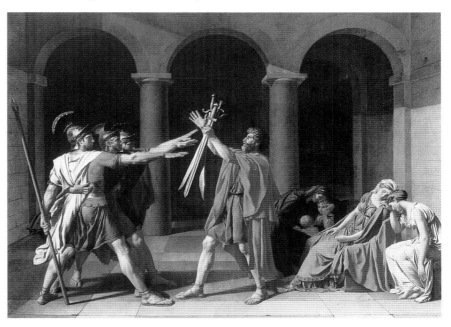

lunched in the company of fellow artists from Russia. Calling for pen and ink, he immediately wrote to the Society, expressing gratitude at some length before going on to say that as of that moment the Society's patronage was no longer required. His struggle to work independently was to continue.

Probably what finally enabled Briullov to sever his connection with the Society for the Encouragement of Artists was closely bound up with the following event. One day in 1827 Briullov was a guest in the home of a leading member of the Russian colony. In the heat of the evening the door was thrown open and into the room strode a glorious woman no more than twenty-five years of age. Her eyes were set wide apart and her pale face was framed by thick, dark, lustrous curls. Gazing at the new arrival, the artist was stunned: before him was the embodiment of his ideal of beauty, mature and flourishing. Her face, the fullness of her figure and her soft, plump arms reminded him of his heroine in *Italian Midday*. Unquestionably Briullov had already heard about the beautiful Countess Yulia Samoilova. Her great

[1] *Ibid.*, p. 103.

wealth was spoken of, as well as her divorce from the notorious hot-headed rake Count Samoilov. Most of all it was whispered that her independent character had not endeared her to the new Tsar Nicholas I. Her house was known as a salon with such noted guests as Rossini, Bellini, Paccini, Donizetti and Massimo d'Azeglio. Soon Karl Briullov became a frequent visitor as well.

Samoilova and Briullov had much in common: independence of character and youthful self-assurance. The countess subsequently became and remained Briullov's only true love.

At this time, under the influence of Romantic aesthetics, a certain aura surrounded people belonging to the world of art. Percy Bysshe Shelley often quoted Torquato Tasso's words that no one deserves to be named creator except God and Poet. Variations of that thought, placing artists on an unattainable pedestal, continuously resounded in the works of the Romantics. Friendly ties between the aristocracy and exponents of art became fashionable in Europe at that time. In this period, Briullov often portrayed Samoilova, visiting her many times in Milan or Corso. She accompanied him on his journeys throughout Italy. In July 1827 they both set out for Naples.

Karl's elder brother Alexander had enthusiastically related tales of the excavations then underway at Pompeii and Herculaneum. These tales awakened in Briullov a desire to see these remnants of antiquity. It turned out to be an overwhelming experience for him. The marks on the street pavement of Pompeii looked so fresh that it seemed the chariots had only just passed by. Even the red pigment used to advertise houses to let or upcoming festivities had survived. The marks left by cups of wine were still visible on tavern tables.

Here and there were small shops with unsold goods still on the shelves... and nearly every threshold bore the inscription *salve* ("welcome" in Latin). It seemed that at any moment a citizen would appear and invite the visitor to escape the heat in the coolness of his inner courtyard. Six long years were to pass between Briullov's first fleeting glimpse of a possible creation and its completion. For the first three years he sketched faces and collected natural objects to enrich his knowledge of Pompeii. The new impressions that he gained also helped him to appreciate and understand contemporary events in Italy and in far-off Russia.

Italy was experiencing a great deal of turbulence. In the 1820s the country had begun a political renaissance. Even after the Russians vanquished Napoleon's army, Italy remained divided and many of its regions were under

Austrian control. The returning Austrian rulers, however, found the Italian populace unrecognizable — their former submissiveness was a thing of the past. The unification of Italy and the ousting of the invaders became the main slogans inscribed on the banners of the day. The liberation movement, or Risorgimento, originating in the eighteenth century as a small grouping of intellectuals, had later become the common cause of the entire Italian people. When revolution erupted in Naples and Piedmont, even women and children took part in the street battles. After the defeat

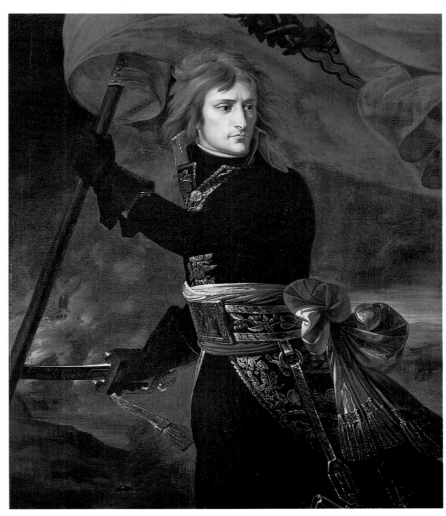

of the French Revolution and the Polish Uprising of 1830, repression grew in Europe. The Risorgimento did not give up but instead went underground. In one way 1831 was a noteworthy year: the revolutionary patriot Giuseppe Mazzini founded the Young Italy Society which thereafter became the vanguard of the liberation struggle. And interestingly, in Italy, perhaps as in no other country, the struggle within literary and artistic groups became suffused with politics. Classicism, which had degenerated into Academicism, continued to advance its time-worn axioms

Antoine Jean Gros
BONAPARTE AT ARCOLE
C. 1797

25

and finally became synonymous with reaction. Patriotism and Romanticism became equated with one another and the Austrian government began to persecute the Romantics as political opponents.

By 1827 Briullov had thoroughly immersed himself in his conception of a grand portrayal of Pompeii. In that year Alessandro Manzoni, an active member of the Risorgimento movement, first published his novel *I Promessi Sposi* (*The Betrothed*), which captivated the Italian public and was translated into many European languages. Manzoni's novel and Briullov's nascent painting had a great deal in common. Apparently the Russian artist not only read the novel, but attempted to illustrate it as well.

Following the exhibition of the completed *The Last Day of Pompeii*, Italian critics found similarities between some of Briullov's images and episodes in Manzoni's novel. Both creators shared the same enlightened idea that true character, even when faced with the terrible blind force of nature, still preserves its moral fibre. The dramatic quality of the devastation by the plague, described in the novel, is equal in intensity to the scenes of destruction in Briullov's painting *The Last Day of Pompeii*. Studying documents dating back to the seventeenth century, Manzoni not only absorbed, but actually incorporated them into his text. In one letter, to the Marchese Cesare d'Azeglio, Manzoni said that the purpose of art is truth and that the depiction of historical events in a truthful manner could not leave readers indifferent.

Briullov also sought to bring historical accuracy to his work. He read the writings of Pliny the Younger describing the eruption of Vesuvius and even portrayed Pliny and his mother in the painting. Briullov executed numerous sketches of the archaeological site, especially the Street of the Tombs and he spent much time in the Neapolitan museum examining pottery, decorations, kitchen utensils and other artifacts unearthed at Pompeii.

While Manzoni's novel appeared just as Briullov began his monumental work, another novel, *Tournament in Barbeta* by Massimo d'Azeglio, was published in 1833, the year the painting was completed. No doubt Briullov knew the author of this novel, also a supporter of the Risorgimento, and shared his ideas. It seemed to them that the portrayal of contemporaries as ancient heroes, perhaps even in togas, was quite artificial and at times simply ridiculous. They both felt that to give proper expression to the thoughts and feelings of the nameless throngs was more important than enumerating the deeds of kings.

Karl Briullov
THE LAST DAY OF POMPEII
1830–33. Detail

26

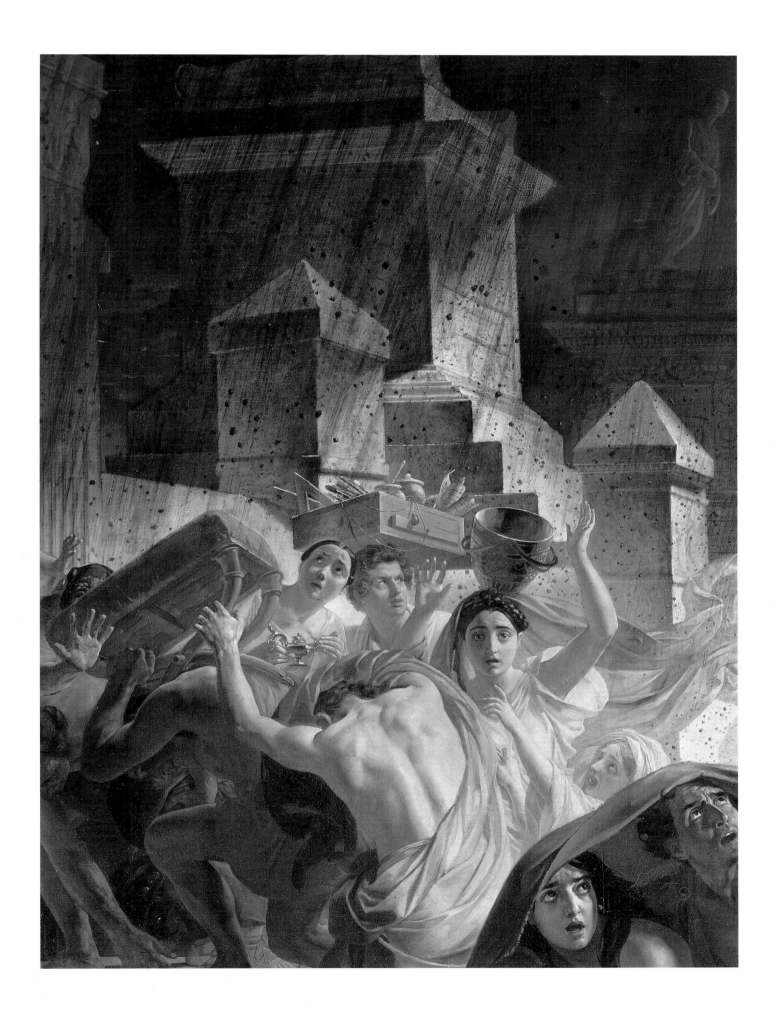

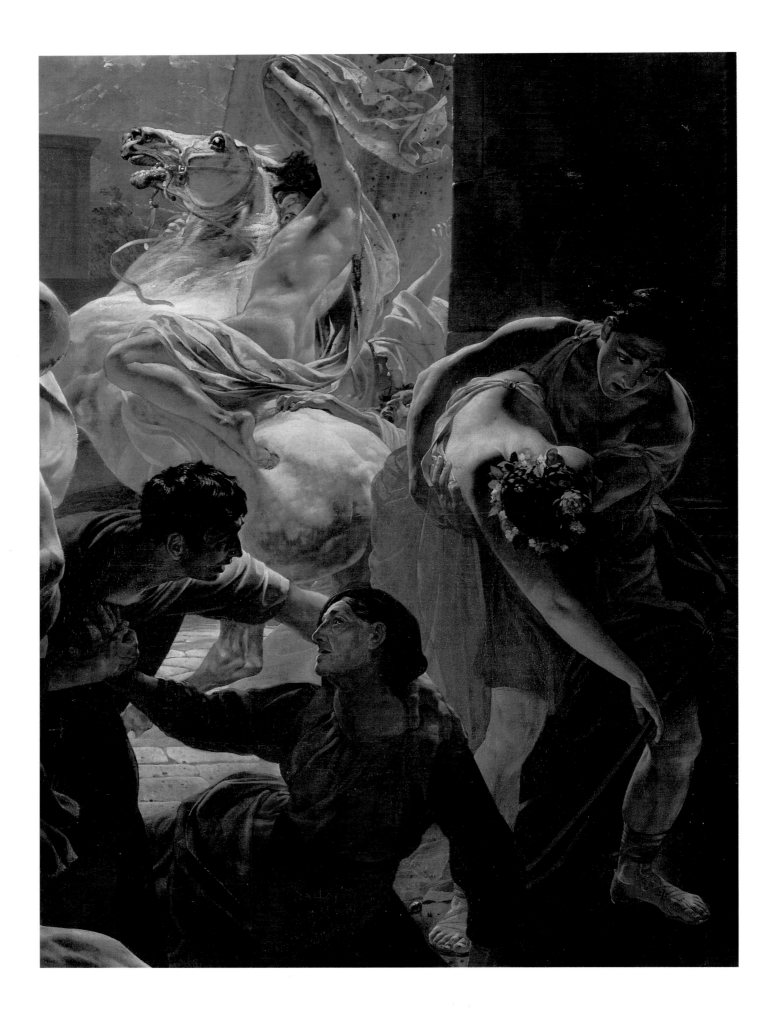

Briullov's impressions of the Italian reality surrounding him as well as his meditations on the destiny of his homeland and his continuing encounters with his compatriots, shaped his interpretation of the tragedy of Pompeii.

While in Rome, Briullov often visited the home of the Turgenev brothers. There he came into contact with Piotr Chaadayev, a progressive philosopher and publicist, who exerted a marked influence on his friend, the great poet Alexander Pushkin. Chaadayev did not conceal his bitter dislike for the repression that was then taking place in Russia. He deplored the corruption, the bribe-taking and meanness of the petty bureaucrats and administrators — themselves servants, yet oppressing those beneath them.

Soon after the suppression of the Decembrist Uprising in St Petersburg, Nikolai Turgenev, as one of the leaders of the movement, was declared guilty of treason and condemned to death. But the governments of Europe refused the Russian government's request that they extradite him, thus making him the first Russian political exile.

On 27 February 1827, Alexander Turgenev received a letter from Prince Viazemsky, in which the poet expressed the feelings of all the Russian intelligentsia: "... a soul, witness to these events, seeing scaffolds lined up to murder people, to slaughter freedom, must not be lost in an ideal paradise. Schiller raised his voice in favour of the oppressed. Byron, who had been up in the clouds, descended to express his indignation to the oppressors, and the colours of his Romanticism often fused into political colours..."[1]

In 1831, in the midst of work on *The Last Day of Pompeii*, Briullov again visited Naples where he had the good fortune to come into contact with a young composer, later to be world-famous — Mikhail Glinka. Glinka had witnessed the uprising in Senate Square on 14 December 1825 and now described it to Briullov. Glinka related that in the summer of 1826, when five of the Decembrists were executed, the smoke from forest fires and burning peat bogs enveloped the city, suggesting that nature itself was in mourning and had lit the torches.

With the execution of the Decembrists and the subsequent repression, Briullov reflected further on the contradictions between the top of society and the people. The uprising in Europe as well had dramatic antecedents in history.

For over three years Briullov had worked on sketches and studies for his painting *The Last Day of Pompeii*. He drew heavily on the letter which Pliny the Younger wrote to Tacitus: "...It was a little after noon; the day was gloomy as if it had lost its strength; the buildings surrounding us

[1] *The Ostafyevo Archives of the Princes Viazemsky*, St. Petersburg, 1899, vol. 2, pp. 170f (in Russian).

were shaking; ... huge crowds of fleeing, terrified people pressed us forward... enormous, frightening thunderclouds filled the sky, zigzags of lightning striking from them... Then my mother began to plead, to beg, to cajole and at last to order me to flee... I, being a youth, was to succeed; she, bearing the weight of her years and illnesses, would die, in peace, knowing she had not held me back and caused my death." From this letter Briullov extracted the image of the flight of Pliny and his mother, only removing

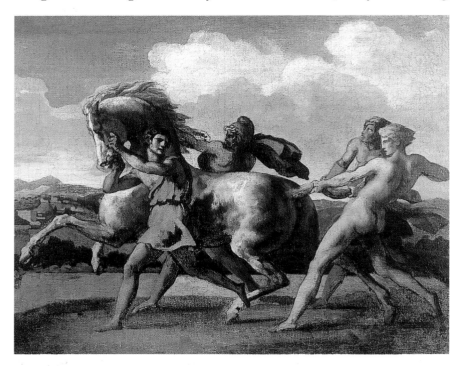

the darkness and choosing the moment when the scene was blindingly lit by a gigantic bolt of lightning. Thus he identified the time and place of the event. Much work was done on the composition of each group, on the faces, the bodies and the poses of his heroes. Deserving of special attention is one of his last sketches — a work in which the artist achieved a fuller expression and fulfillment of his subject than in the painting itself. Here the struggle between the human being and his or her destiny appears with startling force. The centre of the canvas, with lonely figure of a kneeling woman reminds one of a battlefield where man and nature have clashed.

Having decided at last on the form the entire composition was to take, in 1830 Briullov began to put paint to canvas. By the end of the year all the figures had found their proper places and were outlined in two colours. At that point all work on *The Last Day of Pompeii* halted. In his sketches Briullov had not paid much attention to colour, therefore this problem still needed to be resolved. The artist undertook

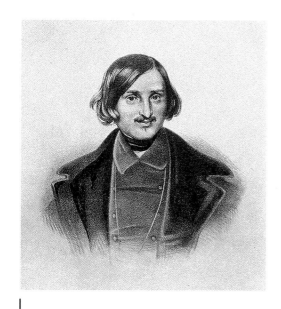

Nikolai Gogol

a journey to Bologna and Venice to seek "advice" on colour from the Old Masters — Tintoretto and Titian. He sought inspiration from the chromatic power of their paintings.

By the middle of 1833 *The Last Day of Pompeii* stood, completed, on Briullov's easel. He felt, however, that something was still imperfect. Each day he came to his studio, gazed for a long time at his work, often touching it up here and there. His feeling of dissatisfaction remained. Later, Briullov related: "Finally, I realized that the light on the pavement was too weak. I repainted the cobblestones beneath one warrior's feet in a lighter shade and the man jumped out of the painting. Then I lit the entire pavement and realized that my work was completed."[1] The next day he opened his studio doors to visitors. Let us imagine that we are in the crowds of Romans viewing the painting for the first time and try to look at it with their eyes, to see what they saw.

Our initial feeling is the pervading atmosphere of tragedy; a black gloom hangs over the canvas signifying the end of life. In the distance, on the horizon, the sky glows a bloody red. It seems that one can hear the rumble of earthquakes, the crash of crumbling buildings and the moans, cries and pleas of desperate people. And, as if it were doomsday itself, the soul of every person is exposed. Observe the greedy man, who, even confronted with death, cannot suppress his passion for money; using the flashes of lightning to see by, and shoving aside the convulsed people, he seeks to pick up jewels dropped in the swirl of commotion. Here we see the young Pliny pleading with his aged mother to gather her strength, to pull herself up, to try to save her life. The moral fibre of individuals under stress, selflessness and dignity in the face of horrifying tragedy are illustrated by a family group where we witness two sons carrying their feeble old father. Not far off a young family, all covered by one cloak, are running for their lives. In contrast we see another group: a young mother and her children, kneeling and praying to God for salvation. Her belief in the almighty power of God is so great that rather than fleeing she concentrates passionately on prayer. Above that group a Christian priest appears, who seems neither to know fright nor to doubt the rightness of God's ways; while nearly in the centre of the canvas, a pagan priest flees in horror and confusion. Yet another image is that of a young bridegroom, standing immobile, ignoring all movement around him, while gazing steadily at the face of his dead bride. Here grief appears even stronger than the spectre of death.

Our attention is riveted by one man, who, amidst this sea of tumultuous humanity, has remained calm but not

[1] *K. P. Briullov in Letters. Documents and Reminiscences of His Contemporaries,* Moscow, p. 71 (in Russian).

31

indifferent. This is an artist — a witness and chronicler of that terrible event. In his face we can easily recognize Briullov himself. The artist wants us to feel that all he has depicted actually occurred, that he is a trustworthy witness, as if he was present in Pompeii on that terrible day. This method — the effect of "being there" — was characteristic of many of the works of the Romantics. For instance, the verses of the Romantic poets were often not autobiographical but nevertheless written in

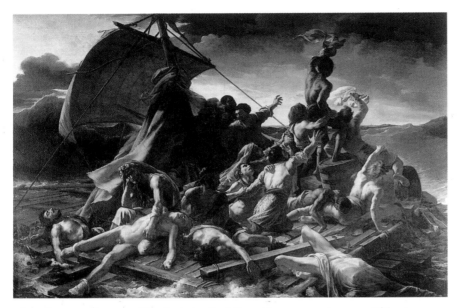

the first person. Trying to bridge the yawning gulf between the centuries — Pompeii was destroyed on 24 August A.D. 79 — Briullov portrayed some of his contemporaries as characters in his painting. The father in one family group was actually a portrait of the athlete Marini; the image of a girl with a jar in another family grouping reminds us of the face of Yulia Samoilova.

In 1834, Nikolai Gogol, in an article devoted to *The Last Day of Pompeii* (published in his book *Arabesques*), noted that all the figures had a three-dimensional quality; that a sculptural effect was enhanced by the use of contour lines delineating each of them. For a multi-figured composition — Briullov's work had almost as many figures as Raphael's *School of Athens* — this method is perfectly suited. And that too was a contribution of Romanticism. The famous French Romantic painter Eugène Delacroix said: "There is one thing that is the most vital for a painting and that is contour. If it is there, the painting will look finished and strong, even if many other details are incomplete or even left out... Raphael achieved a completed look in his work with this method and the same can be said of Géricault."[1] Briullov listened to the voice of Romanticism and obeyed

Théodore Gericault
THE RAFT OF THE MEDUSA
1818–19

[1] *Masters of Art on Art*, Moscow, 1967, vol. 4, p. 142 (in Russian).

Eugène Delacroix
LIBERTY LEADING THE PEOPLE
1831

it while painting his crowded scene. In composing his work, he broke the strict rule of Classicism that each group should be in triangular shape. He attempted to discard the static, bas-relief appearance of figures, seeking a greater sense of the depth of space — he showed, at the end of the street, a terrified horse dragging a Pompeiian who had fallen from his chariot.

He also broke with tradition when seeking to resolve the problems of colour. He did not limit himself to a canonical

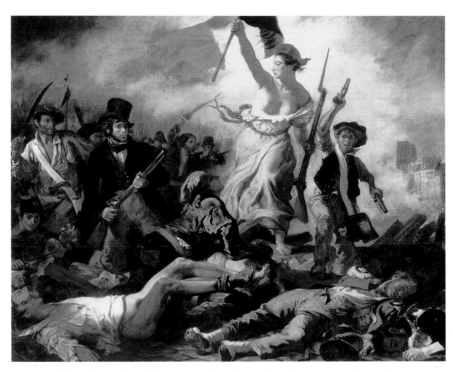

use of localized colours — he breaks them with reflections from neighbouring colour spots. The main and most important thing is that Briullov sought to express events by using many different psychological characteristics. This is the essence of the Romantic method. However, comparing the painting with the main preliminary sketch described earlier, we can clearly discern that the work ended up closer to the Classical vein than might have been expected. Briullov underplayed the tragedy as if he felt it necessary to demonstrate that he still knelt before the altar of ideal beauty. This was noticed by the writer Nikolai Gogol who said that the physical perfection of the characters in some way concealed the horror of their predicament. The beauty of despair and the grandeur of suffering were the main ideas put forward by Briullov. For inspiration, rather than the tragic images of Michelangelo, Briullov returned to the classical principles exemplified in the ancient statues *Laocoön* and *Niobe*, where the fear of death is expressed in

33

a sublimated style.

One must not forget that Briullov's idealized, noble heroes are not only concessions to Classicism, but also reflect the deepest ideas behind the painting: that a physically attractive appearance is an embodiment of high moral and spiritual values. Except for the greedy man and the pagan priest, all the characters in *The Last Day of Pompeii* preserve their dignity in the face of tragedy. For this reason *The Last Day of Pompeii* aroused great and unanimous admiration throughout Italy.

In that period neither native nor foreign artists were able to penetrate the innermost yearnings of the Italian people. Following the publication of Manzoni's novel *The Betrothed*, no other artistic endeavour achieved such extraordinary popularity as *The Last Day of Pompeii* by Briullov. Both managed to touch upon the feelings that united different circles and levels of Italian society. While looking back at the history of Ancient Rome, a thirty-three-year-old foreign artist had not composed a song of military valour, but told a tale of simple human dignity when confronting tragedy. The Italian people, enthralled with the idea of liberation, needed examples from their own history. And Briullov, who quenched that spiritual thirst, enjoyed triumphant success all over Italy.

In France, however, *The Last Day of Pompeii* was rather coldly received. In accordance with Briullov's wishes, the painting was exhibited in the Louvre, at the Salon of 1834. Hanging next to it was the mature Romantic work *Algerian Women* by Delacroix and various historical canvases, strictly following classicist canons: *The Martyrdom of St Symphorion* by Ingres, *The Execution of Lady Jane Grey in the Tower of London* by Delaroche and *The Death of Poussin* by Granet.

The French had already seen, in 1831, Delacroix's *Liberty Guiding the People*, where the central characters were contemporaries dressed in modern costume. In 1832 Balzac's novel *Unknown Masterpiece* had appeared in which an artist is presented neither as a Romantic nor as a Classicist, but as a Realist, that is a harbinger of a new and promising movement. Therefore *The Last Day of Pompeii*, being a combination of the Classical and Romantic features, no longer corresponded to the latest artistic conceptions and failed to evoke a deep response in Parisian art lovers. One critic did indeed write in the Parisian press that if *The Last Day of Pompeii* had been exhibited in the Louvre twenty years before, it would have aroused no less a furore than it had in Italy. Nevertheless the painting managed to excite a

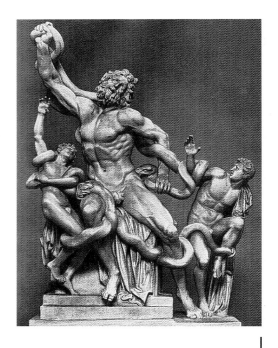

THE DEATH OF LAOCOÖN AND HIS SONS
C. 50 B.C.

34

group of admirers. Briullov's brilliant technique played the greatest role in this recognition. Following the Salon, the jury awarded Briullov the First Gold Medal. Despite that honour, however, he felt insulted. Disappointed, he fled cold Paris for Milan, for the warm and friendly atmosphere of those that had understood him and had received with open hearts the idea of his creation — one that had cost him six years of intense work.

Leaving Briullov for the moment in Milan, let us follow the journey taken by his painting. Since Demidov, who had commissioned the work, intended it as a gift for the Tsar,

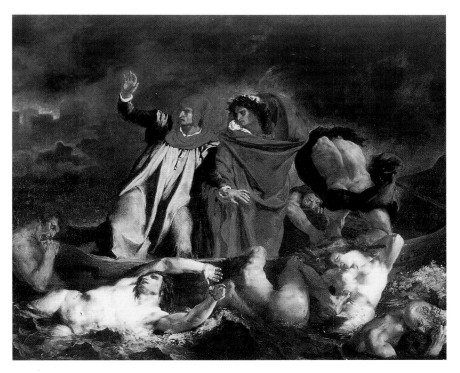

a special frame was constructed in Paris. *The Last Day of Pompeii* took quite a while to reach St Petersburg and it was not finally unwrapped in the palace until August 1834. At last, in September, it was displayed to visitors at the Academy of Arts.

Vast crowds gathered to view the by-now world-renowned painting. The curious streamed through the main doors — all types of people: merchants, craftsmen, even workmen — many experiencing their first visit to the Academy. This in itself was a strange and unexpected development, an upheaval of sorts among the public. Noting this new phenomenon, Gogol declared that Briullov's creation "appealed (though not in the same way) both to an artist with a cultivated taste and to those who had formerly shown no understanding of art."[1]

Even after the closing of the exhibition, journals still continued to publish articles devoted to the painting and

Eugene Delacroix
DANTE AND VIRGIL IN HELL
1822

[1] N. V. Gogol, *Collected Works*, in 7 vols., Moscow, 1978, vol. 6, p. 125 (in Russian).

35

to its creator. The critics fomented many discussions about the mission of an artist and in general about the role of art in society.

Pushkin and Gogol, Lermontov and Baratynsky, Zhukovsky and Glinka, Belinsky and Herzen — all commented enthusiastically on *The Last Day of Pompeii*. Gogol called it "a feast for the eyes" and its creator "a genius".[1]

Pushkin, coming away from the exhibition, felt so moved that he immediately recorded his impressions in verse. But it was Herzen who best expressed the central idea of the painting. In his letters, diaries and notes, he often returned to the theme of *The Last Day of Pompeii:* "On an enormous canvas the crowds of closely packed, terrified people, in disorder, trying vainly to save their lives... they will perish under the force of a wild, senseless, merciless power... against which any resistance is futile. The inspiration for this force Briullov took from St Petersburg."[2]

Herzen took the idea of Pompeii allegorically — he regarded that cataclysmic event as an image of the contemporary tyrannical power in Russia.

While the Russian public was admiring *The Last Day of Pompeii*, the painter remained in Milan and would do so for almost one more year. He viewed himself as a historical painter and those around him thought the same. He considered the numerous portrait and genre scenes he created while in Italy of secondary importance. Time would prove him mistaken. None of his later attempts at historical subjects yielded any serious achievements and *The Last Day of Pompeii* would remain the peak of Briullov's work in the historical genre. At the time, the artist, naturally, believed otherwise. When Briullov returned from Paris, at first he executed primarily historical canvases — one after the other. He was bitterly disappointed by his failures. The first of the historical paintings was *The Death of Inés de Castro*, taken from *The Luciads*, a poem by the famous Portuguese poet Luiz Vaz de Camoëns (*c.* 1524–1580). Briullov depicted the moment in the reign of the Portuguese King Alfonso VI when courtiers rushed into the bedroom of the Infante Don Pedro's morganatic wife and stabbed her in front of her small children. The theme of this painting, with its dramatic tension, was not alien to the artist's philosophy, but nevertheless the picture comes across as a piece of melodrama rather than real tragedy — painted with a high, but cold skill.

Next came a watercolour *The Murder of Prince Andrew of Hungary by Order of Giovanna of Naples* and a thoroughly worked sketch (in oils) *Genseric's Invasion of Rome*, neither

[1] *Ibid.*, p. 119.
[2] A. I. Herzen, *Collected Works*, in 8 vols., Moscow, 1956, vol. 8, pp. 330f (in Russian).

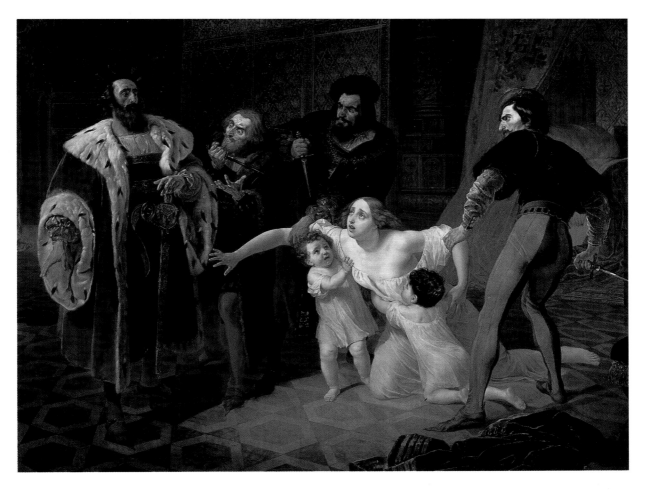

Karl Briullov
THE DEATH OF INÉS DE CASTRO
Based on the subject of Luiz Vaz
de Camoëns's poem *The Luciads*
1834
Oil on canvas. 213 x 290.5 cm
Russian Museum, St Petersburg

of which were ever turned into completed paintings. From that time on Briullov's highest achievements were to be in the realm of portraiture.

During the long years spent in Italy Briullov painted many portraits. In the beginning, while he was still receiving a stipend from Russia, two main types of portrait painting are evident. Psychological representation of a person was what interested the artist above all. In the majority of such works he knew the person depicted quite well. The second type is the "portrait-picture"; among them it is easy to identify those done to commission — they not only convey the artist's coolness, but indeed reveal his virtual indifference to them.

Examples of the latter type are the portrait of the Grand Duchess Yelena Pavlovna with her daughter, the portrait of Davydova and the portrait of Demidov. The painting of Yulia Samoilova with an Ethiopian slave boy and *Rider* represent the type of compositional portrait in which a narrative quality is combined with an air of intimacy.

One feature is common to all the portraits — they all came after Briullov's triumph with *The Last Day of Pompeii*. His happiness at that time was so great that everything seemed full of light and joy to him. He was so emotionally

37

high himself that he tried to portray his characters at the moments of their greatest spiritual triumphs, as if they were somehow raised above the routine of everyday life, as if they had no troubles or pains. The artist felt so happy, so full of strength that he seemed not to notice how hard life was for the typical Italian women he depicted. He passed by and remained indifferent to the chained prisoners who daily weeded the square in front of St Peter's Cathedral. Quite logically, many of the titles Briullov gave his genre pieces at that time begin with the words "holiday" or "dance". During the first period of his stay in Italy Briullov used a variety of media: oil, watercolour, sepia or pencil. One of his finest portraits, marked by a profound insight into character, was that of Prince Grigory Gagarin, Russian ambassador to the Court of Tuscany. Briullov painted all the members of the Gagarin family, but his portrait of the head of that hospitable home turned out best. Briullov was so close to Gagarin, that, when in 1835 he fell ill, he stated in his will that the Prince should inherit all of his paintings. Gagarin took great care of Briullov, liked him and admired him greatly.

In the portrait of the envoy Briullov emphasized his sophisticated intellect, his sensitivity and the depth of his mind. Gagarin gazes out at us with his large, attentive eyes; he has noble, fine, regular features and a high forehead; his appearance suggests a quiet, reserved dignity without any outward sign of vanity. The artist brought out not only what he saw but what he understood about the person as well. For instance, Briullov knew that Gagarin was a well-educated man; he also knew that the Prince was not only a collector of Russian art — by that time Gagarin's home already contained works by Sylvester Shchedrin, Alexei Venetsianov, Piotr Basin, Fiodor Bruni as well as Briullov — but was a genuine connoisseur. Interestingly, Gagarin had his own opinions — he preferred impromptu sketches, done outdoors, to the polished look of a formal canvas. In a fresh, vivid sketch the raw talent of an artist emerges more clearly than in a finished canvas. For the time this was an unusual idea, not only for an amateur but for a professional artist as well.

Although Briullov usually chose bright, primary contrasting colours, he modified his palette for the Gagarin portrait, completely rejecting a decorative approach to his subject and choosing the range of subdued neighbouring hues and the soft fluidity of linear design that would not contradict the character he was portraying. The restrained colours, however, did not prevent him from attaining a chromatic

harmony and from emphasizing the flawlessness of his drawing. Comparing Briullov's image of Gagarin with his painting *Yulia Samoilova with Her Adopted Daughter Giovanina Pacini and an Ethiopian Boy* we can conclude that the Gagarin portrait represents his highest achievement in the "intimate-portrait" style while the *Portrait of Yulia Samoilova* exemplifies the best of the "portrait-painting" style evolved by the young Briullov.

The latter canvas immediately attracts the viewer's atten-

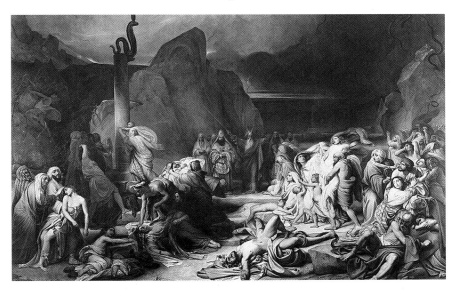

tion by its vividness and spontaneity. In creating an image of Samoilova, Briullov attempted to resurrect his own feeling of ecstasy when he beheld her for the first time in an open doorway. The event depicted is simple — the young aristocrat accompanied by her adopted daughter and the Ethiopian boy enters her home after an outing. The image of Samoilova that we are given accords with the idea which Briullov once expressed that "woman is the highest creation in the universe."

Only at first sight does the composition appear to be a group portrait — finally one senses that the figure of the heroine dominates. Giovanina with her tender trusting nature and the Ethiopian boy with his servile, surprised look merely emphasize the strength and self-assurance of Samoilova's character. The surrounding furnishings were not simply illustrated but shown as grand and opulent: the rich folds of the heavy curtains, the patina of the gilded frame of a picture, and a massively imposing couch. This heavy splendour serves as a foil for the light and gracious central character. As in most of his portraits, Briullov, seemingly enclosed in the limits of one room, expands his vision by including a distant landscape on the horizon.

One of the distinguishing features of Briullov's official

Fiodor Bruni
THE BRAZEN SERPENT
1841

portraits is their pageantry. As a rule the main figure in the composition is surrounded with a number of different accessories. The setting is always easily identified. Often the painting is inhabited by different animals — perhaps a horse or several dogs as in the portrait of Demidov or in *Rider*. The details are not only indicated but poetically expressed. Briullov's conception was that "a single individual is always part of the world." This type of painting, while not extremely complicated in terms of structure, is nevertheless filled with movement.

Briullov understood the world in a vividly sympathetic way and this is fully revealed in his choice of colour. He gave free rein to his decorative sense thus achieving an unusual variety of gradations and shades of colour. It is as if he set himself a task — to create a grand symphony of different modulations of red — the heavy velvet curtains, the shawl in Samoilova's hand, ornaments in the boy's costume, the flowers on the carpet, the brocade covering the wall, and the upholstery of the couch. In the midst of this hot, colourful atmosphere Samoilova seems to be flying in her sky-blue dress made of bright raw silk, similar to the transparent azure of the sky — visible in the depths of the suite. Briullov sacrificed some of the truth in the brightness of colours, but only in one way — by making the natural colours clearer he, as Gogol said, "helped himself to express the inner music that each living object of nature contained."[1]

Rider met with extraordinary admiration from the Italian public and press. The portrait of Samoilova received even greater praise. The critics, thoroughly analyzed the painting, comparing it with portraits by Van Dyck, Rubens and Rembrandt. There were serious grounds for these comparisons: the more Briullov studied the works of those artists the less he remembered his idol Raphael.

Following the exhibition of *Portrait of Inés de Castro*, the artist went from Milan to Bologna. He loved Bologna so much that he began talking of the possibility of purchasing a palace there, in which he could live for the rest of his life. But he was destined never to have a palace nor even a house of his own. Never, not in Bologna, nor in Rome, nor in his homeland.

His love for Bologna was quite understandable. Although he was courted in Rome and Milan, in Bologna the attitude towards him was friendlier and warmer. As one of his contemporaries witnessed, "Briullov was respected here as once Raphael was respected in Rome. He was always accompanied by acquaintances and fellow artists, who tried to catch every word he uttered."[2] Seeing that he was depressed and exhausted after his intense labour on *The*

Karl Briullov
RIDER
Double portrait of Giovanina and Amazilia Pacini
1832. Detail

[1] N. V. Gogol, *Collected Works*, in 7 vols., Moscow, 1978, vol. 6, pp. 124f (in Russian).
[2] "Notes of the Rector and Professor of the Academy of Arts F. I. Iordan", *Russian Antiquity*, 1891, March–October, pp. 144–146 (in Russian).

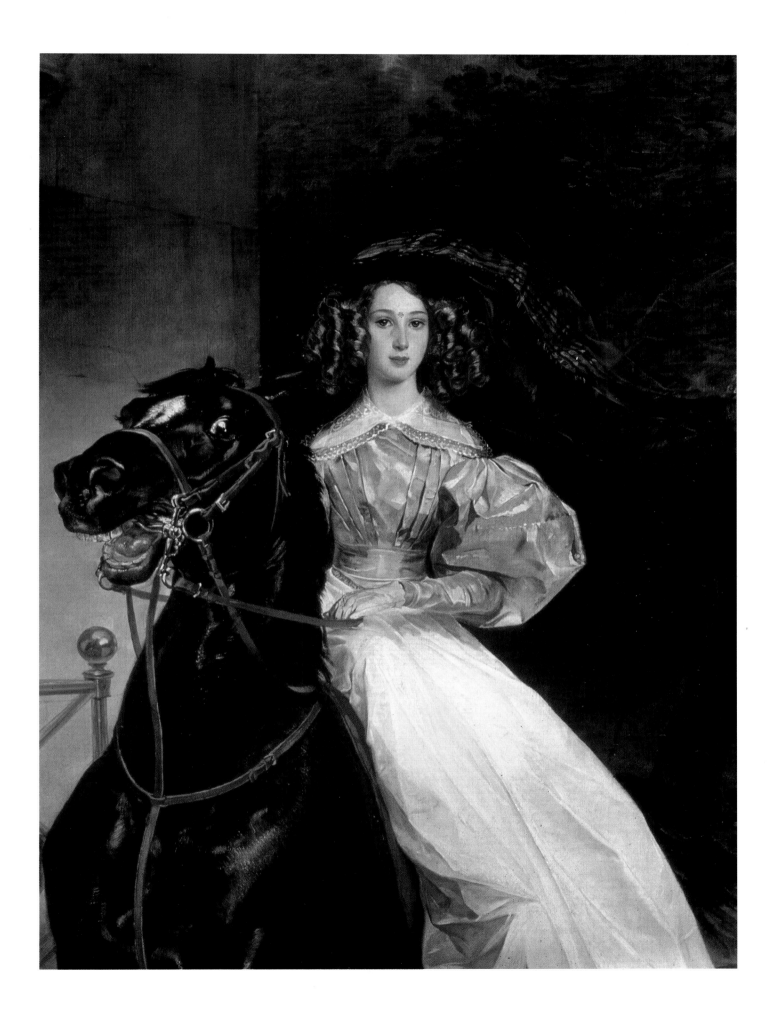

Last Day of Pompeii as well as on numerous portraits and compositions, his friends out of the best of intentions insisted on his giving up work for some time and simply resting. But he instinctively felt that stopping painting would not assist his recovery. On the contrary — being a morally strong individual — for the first time in his life he was in a period of physical and spiritual depression. He was engaged in a search and he knew that his survival depended on his continuing work. Some of his creations from that time bear the mark of his low feelings, his tiredness. One example is a portrait of his good friend, the banker Marietti, and his family. Yet even that year was marked by some fruitful works. In Bologna Briullov became friendly with the sculptor Cincinnato Baruzzi. The warmth of their relations is reflected in the portrait of Baruzzi that Briullov painted with the full strength of his talent.

One more interesting canvas was created in Bologna. Briullov was a keen theatre-goer and in Bologna, which he loved so dearly, he became attracted to the opera. One evening he attended a performance of Gaetano Donizetti's *Anne Boleyn* with Giuditta Pasta (1798–1865) in the leading role. He was so impressed by her singing that he became obsessed with the idea of portraying the singer in the role of the ill-fated queen. The painting sessions took place in Baruzzi's studio. Quite soon a large canvas was nearing completion. But suddenly Briullov ceased work on it — his periods of inspiration were very short at that time and the spark had simply died. A few details still remained to complete the picture. The image was fully developed in concept and resolution. Giuditta Pasta had created a compelling characterization of the English queen, one of the six wives of Henry VIII, accused of treason and going insane in the Tower of London. Her complex inner state was the attraction for Briullov. He chose the moment when the anguished, imprisoned queen, hearing the wedding bells for her rival and successor, imagines that she herself is hand in hand with the King leaving the Cathedral after the wedding ceremony. Her thoughts of her coming execution mix with her hopes — splitting her consciousness. The grin of the insane appears on her face. In her puffy and reddened eyes we can see both fright and hope. With an unsteady hand she touches her head as if to stop the confusion racing through her brain. The artist attempted to portray not only the conflicting emotions of her face but her inner feelings as well. From the pose of the heroine, turning to the window through which the bells can be heard, it seems that the figure of Anne is broken at the

waist and that she would fall to the stone floor were it not for the heavy supporting folds of her velvet dress, edged with yellow raw silk.

Despite valiant efforts to overcome depression, it became more and more difficult for Briullov to continue his work. And then a turn in his fortunes appeared in the person of Vladimir Davydov (known later as Count Orlov-Davydov).

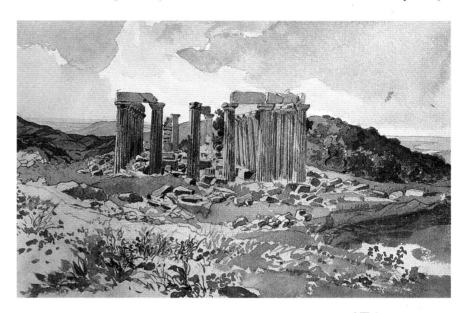

In 1835 Davydov proposed he accompany a scientific expedition to the Ionian Islands, Greece and Asia Minor. Briullov was happy to accept, seeing in the proposal the opportunity to visit the birthplace of art — Greece, and the East, which was full of allure for all the Romantics of Europe. Along the way the artist did much work: using watercolour, sepia and other media he reproduced the intense poverty of Greek villages, ruined temples, and painted a portrait of the Greek insurgent leader Theodoros Kolokotrones, just recently released from prison, and other Greek freedom fighters (*A Wounded Greek*, *A Greek Lying on a Rock*, etc.). Many of Briullov's works later became illustrations for a book by Vladimir Davydov. Among the watercolours created during the trip, the landscapes were the finest, although earlier Briullov had not been fond of landscape art. He was enthralled with the grand nature of Greece. Among the landscapes there are three that emerge as more interesting than others: *The Delphi Valley*, *The Ithome Valley before a Thunderstorm* and *The Road to Sinano after a Thunderstorm*. For the first time in his life the artist tried to work in the open air, producing watercolours, which, though small in size, create a truly monumental effect. In them one feels the breathing of the earth and the presence of Mother Nature. Briullov painted his

Karl Briullov
THE TEMPLE OF APOLLO EPKOURIOS AT PHIGALIA
1835
Illustration for *Atlas for the Travel Notes of V. P. Davydov*
Watercolour on paper. 23 x 29 cm
Pushkin Museum of Fine Arts, Moscow

43

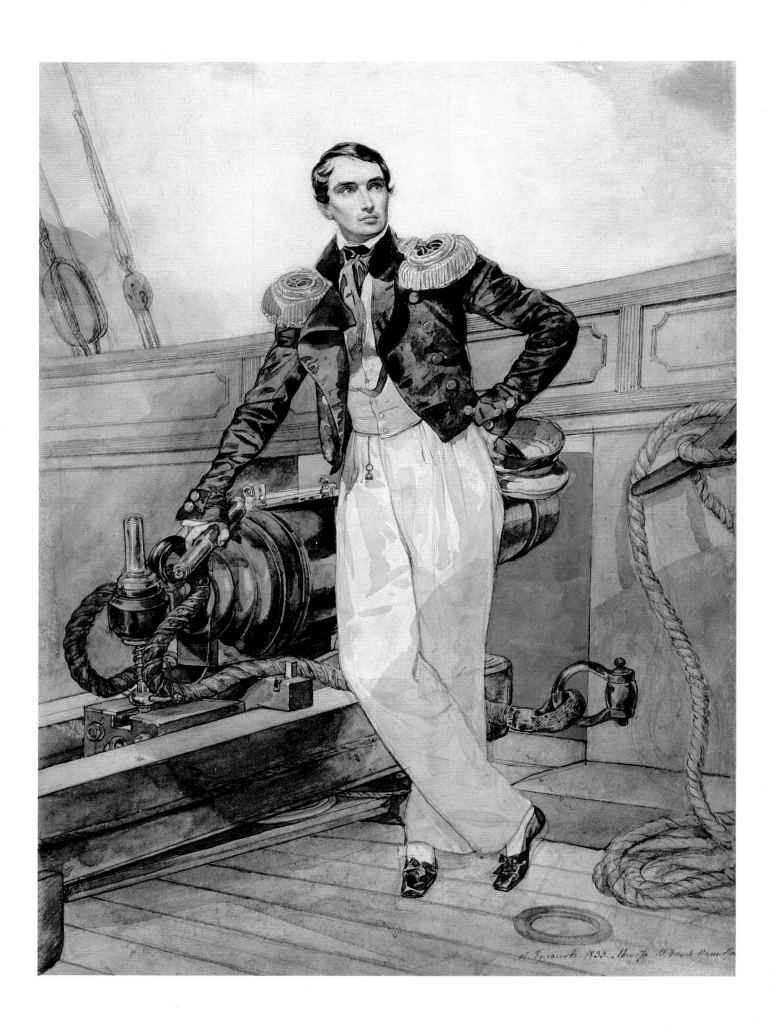

landscapes in a virtuoso manner, either using a multi-layered technique or making them *a la prima* (in a single session) thus endowing his sheets of paper with a light, translucent effect. He did not emphasize the contours of the objects but shaped the forms by having one colour meet another. Sometimes he left unpainted areas of paper which, gleaming white, set a tone to the whole composition.

In Athens Briullov contracted a tropical fever, forcing him to discontinue the expedition. For his recovery he was transferred to the Russian brig *Themistocles*, which was due to sail for Smyrna. The ship's captain, Vladimir Kornilov, would later gain fame for his part in the defence of Sebastopol in the Crimean War.

The first sign of the artist's gradual recovery was that he began to draw on the cabin desk standing near his bed — having nothing better to hand. Kornilov and Briullov became friends, Briullov executing a beautiful watercolour of the captain. New impressions and new acquaintances seemed to inspire fresh strength in him. The voyage on the *Themistocles* turned out to be even more pleasant when in Athens a new passenger joined the ship — Prince Grigory Gagarin. Briullov knew Gagarin at his father's house in Rome and had revealed some of the secrets of art to him. The Prince was now an adult and had recently been assigned to the Russian diplomatic corps in Constantinople. During the voyage Briullov painted portraits of nearly all of the officers aboard the brig, a portrait of Grigory Gagarin and a self-portrait. In Constantinople, where he went with Gagarin, he spent three months, continually painting — on the streets, at bazaars, and in the Russian envoy Butenev's home. The portrait of Butenev's wife and daughter is one of pearls among Briullov's watercolour creations.

Meanwhile the Tsar in St Petersburg had issued an urgent command for Briullov to return immediately to Russia to occupy the post of Professor at the Academy of Arts.

In the inclement autumn of 1835 Briullov began his journey by ship, bound for Odessa. With confused emotions of joy, disturbance, nervousness and fright, he stepped once more onto his native soil after an absence of thirteen years. A cordial reception in Odessa warmed him; at a gala dinner in honour of the European celebrity, the Governor of Novorossiysk Province, Count Vorontsov, proposed a toast to Briullov.

After the hospitality of Odessa, he set out on the road to Moscow. The artist had never been to Moscow before and he also wanted to put off his arrival in St Petersburg. He was already apprehensive about the difference between

Karl Briullov
PORTRAIT OF VLADIMIR KORNILOV ON BOARD THE BRIG THEMISTOCLES
1835
Watercolour and lead pencil on paper, heightened with lacquer.
40.4 x 28.9 cm
Russian Museum, St Petersburg
Vladimir Alexeyevich Kornilov (1806-1854), Captain-Lieutenant, later Vice-Admiral, a hero of the Crimean War

his new position as a Russian artist in the capital of his own homeland and his former triumph as a visiting celebrity. On 25 December Briullov arrived in Moscow.

He remained in Moscow almost half a year, meeting new people and renewing old friendships. Many of those encounters influenced his outlook — he had after all been separated from his homeland for many years. There were two main meetings which affected not only his mind and soul but deeply influenced his creative work as well. Briullov must have heard about the prominent Moscow portrait artist Vasily Tropinin — otherwise it is doubtful that on his second day in Moscow he would have been invited to Tropinin's home for dinner. Briullov immediately liked Tropinin for his work, for his steady temperament and his wisdom, gained at the heavy cost of a hard life. Only when he reached the age of forty-seven and was already widely known as an artist had Tropinin gained his freedom from the serf-owner Morkov.

For hours Briullov scrutinized the works of his older colleague. They captured the ordinary, vital image of Moscow with the unhurried rhythm of the life led the local nobility. He was greatly impressed by the realism of Tropinin's paintings. Fairly soon those impressions were reflected in Briullov's own work as well: for example, in the painting *Svetlana Divining before a Mirror* after a poem by Vasily Zhukovsky, a famous Russian romantic poet. The girl Briullov portrayed seems to be a sister or friend of Tropinin's *Lace-Maker*, *Spinner* or *Gold Embroiderer* rather than the character from Zhukovsky's poem.

Tropinin began painting a portrait of Briullov during which process the sitter unconsciously observed and absorbed the secrets of the other's mastery. Tropinin attempted to engage his model in conversation, trustingly sharing his thoughts about art: "The best teacher is nature; you must like it with the whole of your soul and heart and it (nature) makes a man cleaner and more moral..."

There was one more thing which impressed Briullov: when he looked at Tropinin's sketches for the portrait it seemed to him that he was looking into a mirror which reflected not only his haggard, worn-out face but also the confused state of his soul — his fear of bureaucratic St Petersburg and of what the immediate future would bring, as well as his tiredness. This was an absolutely new method of work for Briullov — he had never done any sketches of this type for his portraits; during the preliminary phase he only sought after better composition.

But the greatest surprise was the appearance of the

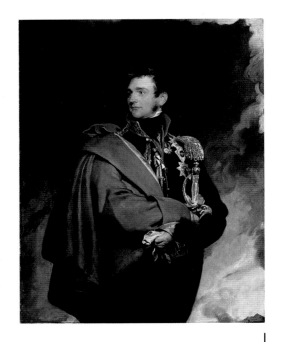

Thomas Lawrence
PORTRAIT OF COUNT MIKHAIL VORONTSOV
1821

Karl Briullov
PORTRAIT OF PRINCESS YELIZAVETA SALTYKOVA >
1841. Detail

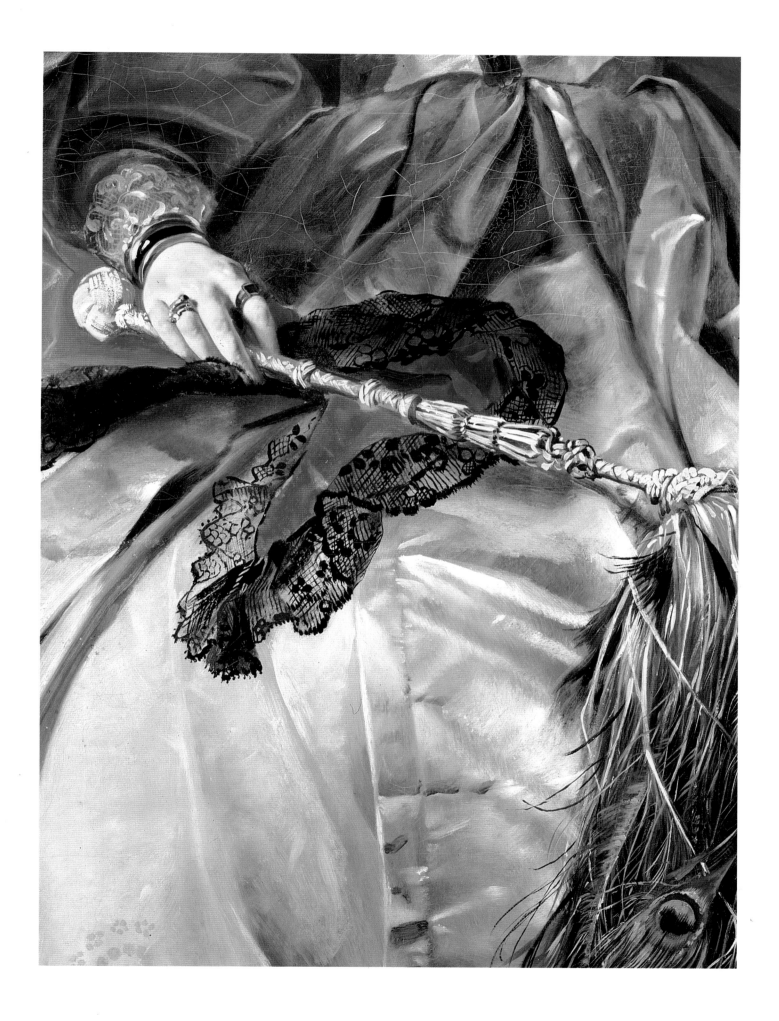

completed canvas. When Tropinin's portrait of Briullov was done, it showed a gracious, affable, smiling man with Apolline curls, posing against the background of Mount Vesuvius. Here Briullov is depicted in the way he was perceived, in the context of general admiration, by artistic circles in Moscow.

During his time in Moscow Briullov worked eagerly and selflessly. While journeying back to Russia he had had no opportunity to work in oils — he had missed his palette and even the sharp smell of oil paints. At first in Moscow he lived at the home of Count Alexei Perovsky (a writer who published his works under the pen-name Anthony Pogorelsky), where he was given a large, beautiful room to

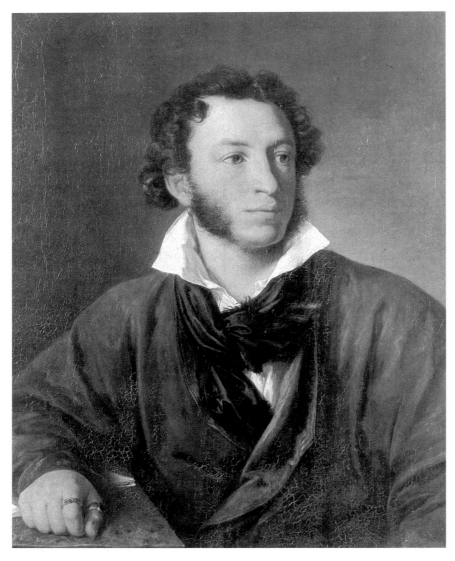

use as a studio. Briullov painted a portrait of his host, produced the work *Svetlana Divining before a Mirror* for him and he also drew an illustration for Pogorelsky's novel *A Convent Girl*. Briullov later moved to Makovsky's and then to the home of the sculptor Fiodor Vitali. Soon Vitali

Vasily Tropinin
*PORTRAIT OF THE POET
ALEXANDER PUSHKIN*
1827

48

Anonymous artist
*View of the Staircase
in the Academy of Arts
in St Petersburg*
1830s–1840s

[1] *Correspondence of A. I. Turgenev with
Prince P. A. Viazemsky*, Petrograd, 1921,
vol. 1, issue 6, p. 133 (in Russian).
[2] A. S. Pushkin, *Complete Works*,
in 16 vols., Moscow–Leningrad, 1949,
vol. 16, p. 181 (in Russian).

began work on a bust of Briullov, and he in turn began to paint a portrait of the sculptor at work in his studio. Once Briullov heard a hammering at the door in Vitali's house. A small man with a distinctive profile and quick eyes in an expressive, lively face burst into the living room. Before being introduced Briullov already knew that the visitor was Pushkin — so strong was the likeness between Tropinin's well-known portrait and the man before him.

Pushkin had been informed of Briullov's stay in Moscow, and was eager to meet the artist face to face. On 2 May Pushkin arrived in Moscow and by 4 May he wrote to his wife that he had already been introduced to Briullov. The poet and the artist soon became very close, often visiting each other, endless discussions on all manner of subjects ensuing. Thus Karl began to learn about the state of his homeland. Once the Decembrist Nikolai Turgenev had said: "... in such a despotic country as Russia, where the press is deadened by censorship one can form an idea of public opinion only from talks and handwritten, unpublished literature."[1]

Pushkin visited Alexei Perovsky's house to see the Briullov paintings kept there. He wrote to his wife about his new acquaintance that he "liked him very much" and that "he is a real artist and a nice fellow."[2]

However threatening Briullov perceived St Petersburg to be, he still had to go there. His friends accompanied him as far as the first post station and then bade him farewell. From there Briullov undertook his lengthy journey to the northern capital of the Russian Empire.

After a long separation Briullov returned at last to the city where he had been born thirty-six years before. The face of St Petersburg had changed. Much was entirely new. The light and gracious creations of Carlo Rossi — the Alexandrine Theatre on Nevsky Prospekt, the Mikhailovsky Palace, and the Senate and Synod buildings opposite the Bronze Horseman (monument to Peter the Great) helped to complete the "strict and severe" look of the capital. Most of the ambitious constructions were completed; debris had been removed and new trees had been planted. The balance between greenery and stone gave the city a special beauty. In the suburbs, growing like mushrooms were previously unknown factory buildings with their own shops and single-storey barracks for the workers. Briullov had returned to his homeland when Russia was undergoing the transition to capitalism.

On arrival in St Petersburg Briullov fell ill. The Academy of Arts was forced to postpone the meeting with its world-renowned pupil until 11 June. In the one hundred years of

its existence the walls of his *alma mater* had not witnessed anything similar to the celebrations that greeted Briullov. He was met by the student choir, followed by the thunderous sounds of a brass band, and toasts were raised over beautifully decorated, heavily laden tables. Although Briullov himself used to say that he hated gala dinners, the sincere warmth of the atmosphere gave him a feeling that all was not perhaps so bad in the state and within the Academy as he had been led to believe in Italy and in Moscow. But his hopes soon evaporated. Some days later he was summoned to an audience with Nicholas I. He attentively observed the regular features of the Tsar's face, a face that could be considered handsome except for the icy coldness of his glassy, protruding eyes.

When Briullov was ushered into the Tsar's presence, instead of a greeting the monarch said: "I want to commission a painting from you." Briullov silently bowed. "Paint for me Ivan the Terrible and his wife in a Russian *izba*, kneeling before an icon, and through the window show the conquest of Kazan." Briullov felt perplexed, meditating. Much depended on his answer to the Tsar. He would either object or obediently fulfil his sovereign's wish, against his own will. That moment was the start of a sort of combat — unusual and unequal. After a brief silence, Briullov finally asked: "Can I paint the siege of Pskov instead?" Nicholas I said: "Yes."[1] From that first meeting until the last day of his stay in Russia, Briullov would always express his independence towards the Tsar. One of Briullov's contemporaries remembered: "That was typical of him. He was independent and non-ingratiating by nature and did not grovel before the golden calf or before the powerful idol of court honours."[2]

Only two weeks after his gala reception at the Academy, Briullov, accompanied by his friend and former classmate Fiodor Solntsev, departed for Pskov. He had long dreamt of painting a large canvas dealing with an episode from Russian history. Alas, the inspiration that he had felt when standing in the Forum at Pompeii now eluded him. His spiritual state was not conducive to a flight of creativity; inertia following his illness, his emotional high at the Academy gala was followed by his depressing audience with the Tsar. He wandered the streets of Pskov hardly doing any drawing. He wasted time at frequent parties and dinners given in his honour by the local nobility. Work on the painting would last eight years but it would never be completed.

Returning from Pskov, Briullov became drawn into the activities of everyday life. He needed to furnish his new

Vladimir Golicke (?)
PORTRAIT OF NICHOLAS I
1840s

[1] *K. P. Briullov in Letters...*, p. 115.
[2] "Notes of Count M. D. Buturlin", *Russian Archives*, 1898, vol. 10, p. 177 (in Russian).

apartment at the Academy, to see what was going on around him and to spend time with his brothers Fiodor and Alexander. (The latter was now one of the most famous architects in the capital.) In this period he created several portraits, the best being those of General Count Vasily Perovsky and of the poet Nestor Kukolnik. Poles apart not only in form but in content — the former continuing Briullov's "portrait-painting" trend without the feeling of a cold, commissioned, pompous work, having instead warmth, sensitivity and psychological insight like all the portraits of Samoilova. The later painting of Nestor Kukolnik represented Briullov's "intimate-portrait" style.

Briullov had known Perovsky for many years, loved and respected him for his lofty mind, honesty, bravery and his sympathy for the Decembrists. Before and now, Perovsky, in the position of Governor of Orenburg Province, managed to combine a brilliant career with a liberal way of thinking and acting. It was Perovsky who played host to Pushkin when he went to Orenburg to collect material about Yemelyan Pugachov, the leader of the peasant uprising, for his book *The Captain's Daughter*. Perovsky shielded Pushkin from the secret surveillance of the police. Perovsky was not easily intimidated and was not afraid to try to ease the hard life of the Ukrainian poet and artist Taras Shevchenko. Briullov portrayed Perovsky in a heroic fashion trying perhaps to show that even in that depressing atmosphere of Nicholas I's Russia, one still could find stoic, highly moral and brave individuals.

The other part of Briullov's soul and the reality which surrounded him at that time was expressed in the portrait of Nestor Kukolnik. His appearance was completely different from Perovsky's — instead of a heroic look, suggesting readiness to act, Kukolnik had a thoughtful, introspective face. The image of Kukolnik seemed to reflect the atmosphere of an era dominated by a sense of insecurity. The sense of not being needed and of the pointlessness of struggle is exhibited in his frail face. This was a new departure for Briullov — a plunge into as yet unexplored psychological interpretations of an individual's character. All of Briullov's contemporaries knew him as an artist who, in his work, asserted the joy of life, showing people at their best moments and in the best period and mood of their lives. The portrait of Kukolnik is somehow opposite in flavour. Briullov succeeded in catching the expression in the poet's sad eyes: gloomy, intense, as if he is looking into the viewer's face but at the same time trying to hide his real feelings. His figure is bent making him seem older than he actually was. His hands are relaxed and

inactive. The feeling of isolation is created by an enclosed atmosphere — purposefully created. It is as if he is surrounded by a solid, windowless wall, onto which his dark silhouette is cast. In addition to the tangibly real wall with a breach in it exposing the brickwork like a wound, Briullov

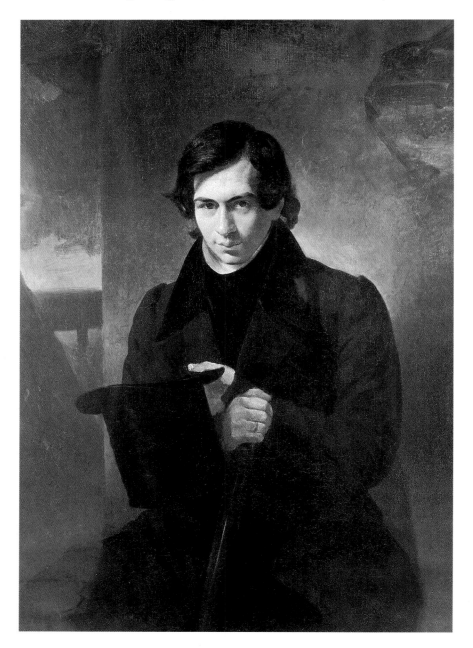

introduced on the left side another, not easily identifiable obstacle. They meet at a narrow angle, making the glimpse of the natural world between them a disturbing element intruding sharply into the space of the picture. The self-contained composition and the static posture are somewhat broken by the restless illumination. The reflexes of the uneasy light touch the poet's forehead with its protruding superciliary ridge and pick out in the darkness his weak hands holding a walking stick. The light diffused on the

Karl Briullov
PORTRAIT OF NESTOR KUKOLNIK
1836
Oil on canvas. 117 x 81.7 cm
Tretyakov Gallery, Moscow
Nestor Vasilyevich Kukolnik (1809–1868), writer

Karl Briullov
THE SIEGE OF PSKOV BY THE
TROOPS OF STEPHEN BATORY,
KING OF POLAND, IN 1581
1839–43

Oil on canvas. 482 x 675 cm
Tretyakov Gallery, Moscow

Karl Briullov
CRONUS, THE GRACES,
CUPID AND THE POET
1837–40

Black chalk on paper.
19.5 x 27.2 cm
Institute of Russian Literature
(Pushkin House), St Petersburg

canvas dissolves the locality of colour. This is the first of Briullov's paintings in which the academic, conventional colour range is completely lost. Indeed this is one of the first creations in Russian painting where the artist achieved such expressive and at the same time reserved use of colour.

Briullov was first introduced to Kukolnik by the composer Mikhail Glinka. The composer respected and esteemed quite highly the poet's ability to comprehend music. Glinka composed a cycle of romances *Parting with St Petersburg* — the most famous one being *Doubt*. The fact that it was Glinka who introduced Briullov to Kukolnik prompted the artist's initial friendly feelings to the poet. Kukolnik himself was not an easy companion. He was unattractive and awkward. His nature was a strange blend of timidity and shyness with unrestrained fervour. On one occasion he might proclaim very lofty spiritual ideals, on another evil, cynical ones. The artist was greatly attracted by the challenge involved in attempting to depict this mixture of conflicting emotions. While working on the painting, Briullov became better acquainted with Kukolnik and their mutual interest in each other grew. Eventually Glinka, Briullov and Kukolnik formed a friendly trio, a "brotherhood" as they called it.

What did that union represent? First of all, what made all three of them feel so close to each other was their creative work — their all belonging to the world of art. At Kukolnik's home Glinka composed his *Fantasy Waltz* and while he would be playing variations on the piano of *Ruslan and Liudmila* Briullov would be nearby, sketching designs for the costumes and sets of the opera. Briullov passionately loved music, while Glinka drew passably well, although just as an amateur. Briullov and Glinka alike were destined to introduce Russian art to the European scene. The composer felt depressed about the failure of the first performance of *Ruslan and Liudmila*. Only in a small circle of friends did he find mutual support and understanding. This support is the evidence of the true, creative character of the "brotherhood".

The year 1837 arrived. One day in January, Briullov's pupil Apollon Mokritsky noted in his diary that Pushkin and Zhukovsky had visited Briullov's studio. Mokritsky recorded that Briullov "feasted them with his most recent sketches and watercolours." When they got to the immensely funny scene of *Arrival of Guests at a Ball in Smyrna*, even the reserved Zhukovsky laughed so hard that he cried and Pushkin fell to his knees, pleading with Briullov to present him with the watercolour. Unfortunately the work had been commissioned and already sold. The artist swore that he would produce a copy for Pushkin and that he

Karl Briullov
*ARRIVAL OF GUESTS AT
A BALL IN SMYRNA*
1837
Watercolour on paper. 32.6 x 24 cm
Art Museum, Kirov

would, in the next few days, begin a portrait of the poet himself. The duel in which the great poet would be fatally wounded was just two days away...[1]

A whole era in Russian history can be said to have ended with the death of Pushkin. His work became an example and a standard for creative people to follow. If he had survived the duel, perhaps the lives of many people would have been different. Maybe Gogol's death would not have been so tragic; perhaps Briullov's work too would have gone in another direction. It would be difficult to put it better than Gogol: "Pushkin is an extraordinary phenomenon and perhaps a unique phenomenon of the Russian spirit: he is the Russian man in his developed state, as he will probably appear in two hundred years time."[2] Nothing could assuage the tremendous loss felt not just by that one author but by the whole of Russia.

In those tragic days Briullov took to his bed with a fever. At Briullov's request, Mokritsky rushed to Pushkin's apartment. He returned with a sketch of what he had found there: two candles burning near the poet's head, his worn-out frock coat covered with a shroud, while his face, white and immobile, radiated peace and sublimity. As soon as he could rise from his bed, Briullov became obsessed with the idea of producing something to commemorate the dead poet. He drew preliminary sketches for the intended work and created the frontispiece for an edition of Pushkin's collected works. Briullov's studio resounded with recitations of Pushkin's verses. The death of the poet drew his friends close together: Zhukovsky, Briullov, Glinka and Matvei Vielgorsky. The last composed two romances to Pushkin's poems: *The Black Shawl* and *Scottish Song*; Glinka in his opera *Ruslan and Liudmila* composed a special section, the second song of Bayan, intended as a requiem for the beloved poet dead before his time. Briullov, for his part, portrayed Pushkin as a youth.

Only when Briullov crossed the threshold of the Academy of Arts not as an honoured guest but as a professor did he understand the changes that had taken place there in the years of his absence. The reform of 1830 had changed everything: the way of conducting classes, the timetabling and even the very atmosphere were different. The Academy was now under the administration of the Ministry of the Imperial Court. The Academy's board obediently fulfilled the Tsar's will. The value of each professor was measured not by his creative work, but by the service record which reflected his marks, orders, and the numbers of gifts he had received

[1] A. Mokritsky, "Reminiscences of Briullov", *Notes of the Fatherland*, 1855, No. 12 (in Russian).
[2] N. V. Gogol, *Collected Works*, in 7 vols., Moscow, vol. 6, p. 63 (in Russian).

from the Tsar — snuff-boxes, diamond rings and the like. Briullov as a teacher is a separate subject which demands extensive treatment. He is not credited with inventing any special method of teaching, unlike Alexei Venetsianov or later Pavel Chistiakov. But if we collect together all the evidence from his pupils, we can gain a rather precise image of his activities as a professor. He introduced a number of new ideas to the numbed, decaying academic system. First of all, a different attitude to nature, to the classical heritage and as a consequence to artistic methods. He often repeated to his students: "The copying of ancient art that you do in the galleries is as essential to becoming an artist as salt is to food. In classes of life drawing try to show the life within the human body; you must comprehend the perfect beauty of it." Briullov was against rendering models, usually simple people from Vasilyevsky Island, "in the manner of Greek statues". He asserted the principle that the inner logic of the entire subject should be grasped, that any small detail is an inherent part of the whole and that "a hand could be as expressive of a person's inner state as his face."

Briullov was strictly against the mechanical copying of the Old Masters. He felt that an artist should thoroughly study the tradition, but to imitate an artist from the past was a waste of time.[1] His concept was that the direct observation of the subject was only an initial stage. Briullov led his pupils from an outward similarity towards a keen insight into character. He also warned his pupils not to be captivated by one single manner, but to draw inspiration directly from the subject before them. In solving problems of colour, Briullov considered it vital that all the colours should appear as natural as possible, so that "the paint should not be seen."

Briullov, quite naturally, taught his young pupils using his own methods — but to his imitators he angrily said: "Don't mimic me." He felt that it was a mistake made by many professors to encourage their students to imitate. Among his pupils the ones who later became real artists were not those who imitated him, striving to become a "small Briullov",[2] but rather those who used his advice to travel their own road in art. Here is a characteristic example: the historical trend remained dominant at the Academy, yet Briullov, taking into consideration the individual inclinations of his own pupils, encouraged the study of landscapes, portraits and genre scenes. He taught not only what he knew and could accomplish himself but also what he had never done. When Pavel Fedotov brought him his sketches of genre scenes, Briullov sternly told the young

[1] N. A. Ramazanov, "Reminiscences of K. P. Briullov", *The Muscovite*, 1852, No. 6, p. 96 (in Russian).
[2] *K. P. Briullov in Letters...*, p. 221.

artist: "It would be blasphemy if you were not to paint these scenes."[1] In this he expressed the highest honesty and courage of a great artist who could grow seedlings of a new trend that were not characteristic of his own style. That was one of the main reasons why masters such as Fedotov, Agin and Shevchenko emerged under his tutelage. Briullov organized a "home Academy" where he educated his own pupils. While not ignoring the question of their

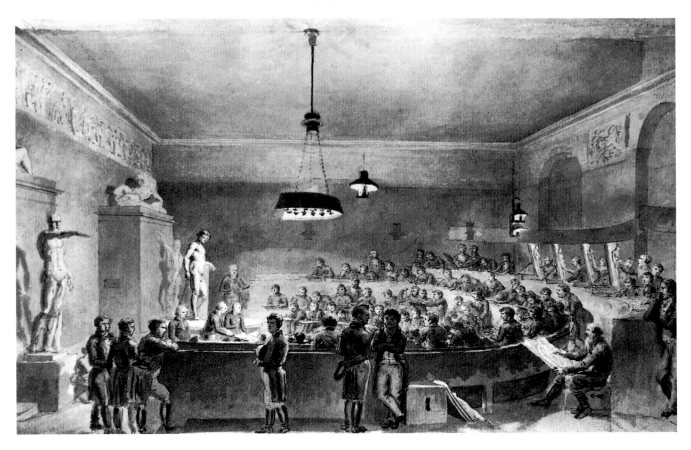

mastery of technique, he felt that the most important thing was to shape their mentality and to influence their spirits. He gave them lessons in "independence" through the example of his own behaviour. The authorities at the Academy were against serfs being admitted as students. Briullov had a great number of serfs in his class — more than any of the other professors. Through the personal interference of Briullov, Ivan Lipin and Taras Shevchenko were freed from serfdom, afterwards becoming his pupils. If it were not for the collective efforts of Briullov, Venetsianov and Zhukovsky, we would hardly know of such a great writer and artist as Taras Shevchenko.

The name of Alexei Venetsianov does not appear in these pages by accident. Briullov was so far ahead of his time that, among St Petersburg artists, at that time, he had no one with whom he could communicate as an equal. When

[1] Ya. D. Leshchinsky, *Pavel Andreyevich Fedotov*, Leningrad–Moscow, 1946, p. 130.

he returned to Russia he mainly associated with writers, actors and members of intellectual salons. Among the artists that he met he became closest to Venetsianov, almost an antipode to Briullov in all respects. Briullov was a brilliant maestro acknowledged by Europe, and still he took an interest in the modest Venetsianov, who lived mainly on the small secluded estate of Safonkovo in Tver Province. Probably Briullov was especially attracted by the old artist's profound knowledge of Russia and especially of the Russian peasantry. He regarded Venetsianov's paintings as part of Russian life. Everything he did — from the subjects to the techniques — was absolutely different from

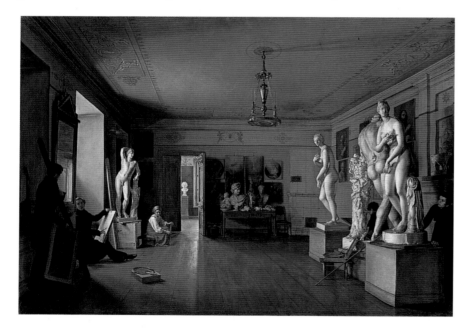

Briullov's work. Yet they did have something in common: Venetsianov also preferred to show his characters at the best moments of their lives.

By the middle of the 1830s Venetsianov not only had many of his own pupils, but he had worked out a unique system of instruction drawn from his own hard-won experiences. If one compares the opinions of both masters concerning the primary goals of teaching, it emerges that they shared almost the same views. Venetsianov lost many of his pupils to Briullov. This circumstance in other cases might have caused a quarrel, but these two artists managed to rise above it. Unfortunately, though, hardly any of their pupils would truly absorb the lessons of either teacher.

As the 1830s drew to a close, fortune, that had favoured and protected the Russian artist Karl Briullov, suddenly ceased to smile upon him. Adversities began to plague the artist. It was probably just coincidence, but all of this began with the death of Pushkin.

Alexander Alexeyev
*THE WORKSHOP
OF ALEXEI VENETSIANOV
IN ST PETERSBURG*
1827

58

Briullov failed to realize his dream of painting a monumental work. Despite all the personal influence exerted on his behalf at the Tsar's court by his good friend Zhukovsky, Briullov did not receive the commission either for mural paintings in the recently finished Pulkovo Observatory near St Petersburg or for the re-decorating of the Winter Palace rooms recently restored after a fire.

The work on *The Siege of Pskov*, commissioned by the Tsar, proceeded slowly and tortuously. It was the biggest canvas of Briullov's career, depicting a positive subject from Russian history, and despite all his efforts was a dismal failure. The first failure of his life. The creation of a historical painting turned out to be beyond him. There were several reasons. The Tsar repeatedly interfered in the process of the work — but that was not the main cause. Russian historical painting as a whole was undergoing a crisis at that time. The Academy rejected subjects from Russian history in favour of established Old and New Testament themes. Classicism with its lofty and heroic ideals had died with the defeat of the Decembrist Uprising. Neither heroism nor valiant patriotism were to become features of Nicholas I's age. There was nothing to sing about in Russia. The Academy of Arts still continued to "churn out" paintings according to the out-of-date recipes and strict formal dictates of a moribund style. Classicism degenerated into a cold, spiritless Academicism, lacking any fresh ideas. A competition announced by Alexei Demidov for a painting dedicated to the deeds of Peter the Great was a complete failure, and that despite the fact that the first prize was 10,000 roubles. The best artists, such as Briullov, Bruni and Ivanov, turned down the opportunity to take part. There was a general awareness that it had become impossible to paint a historical subject according to the old style, although nobody knew how to do it in a new way. Briullov was quite full of enthusiasm when he sketched clothing and utensils and visited the site where the siege of Pskov had taken place. He tried, as had Pushkin in the drama *Boris Godunov* and Glinka in the opera *Ivan Susanin*, to create a work in which the main hero would be the people. Yet while being well acquainted with the life of the Russian intelligentsia, painting dozens of portraits of its representatives, he still did not know the Russian people. All of his heroes were depicted in the most academic fashion, for all that a great visual imagination was at work. *The Siege of Pskov*, strictly speaking, was a creation of the academic style. Briullov admitted defeat in the autumn of 1843, putting his signature on the back of the canvas rather

than the front. He would never touch the painting again. Briullov's great thirst for companionship was satisfied, in a way, by the fraternal atmosphere within the "brotherhood". But as he grew older, the artist suffered more and more from loneliness. There are very few people on earth who never dream of finding a soulmate. Briullov himself used to say that "a soul without a match has no value and no aim." When he met Emilia Timm, a young and gifted pianist, his dream seemed to have come true, but their marriage broke down after only a few months.

To Briullov's great joy, at that juncture, Yulia Samoilova returned to Russia, to settle an inheritance problem. She enveloped the artist with tender, friendly support. Completely ignoring the opinions of high society, she often invited Briullov to her country estate of Grafskaya Slavianka near St Petersburg. Partly as a token of his appreciation, Briullov began to paint another portrait of Samoilova. This time he showed her leaving a masquerade with her adopted daughter Amazilia Pacini. This canvas has more features of a "painting-portrait" than of a "portrait-painting". Everything in this work serves to evoke in the viewer a feeling of great admiration for the proud and beautiful woman depicted. The architectural form of the hall she is in reminds one of the great fantasies of Piranesi. The space, with a complex intertwining of columns and arches, seems to stretch to the endless depths of the composition. The column (evidently exaggerated in its might and volume) beside which Samoilova and Amazilia stand is draped with the massive and heavy folds of a crimson curtain, as if emphasizing the physical perfection of the woman who is portrayed and her spiritual world, her independence and indomitable spirit. Samoilova does not simply stand, ready to step down — she seems to have always been there, like a statue, like a monument of a strong personality. All the elements of her figure, her shoulders and arms, her long curls, seemingly cast in bronze, and her heavy, whimsically draped dress — everything suggests a sculptural quality.

The second title of the picture, *Masquerade*, defines Briullov's hidden concept of creation. All life resembles a grand masquerade in which everyone wants to be taken for somebody else. A man who has come as a sultan is pointing out a young girl in an oriental costume to another disguised as Mercury. "Mercury" is bending over the "sultan's" shoulder, whispering in his ear. Casting a sideways glance is a character dressed as a bearded Mephistopheles, with a devilish smirk. Only Samoilova, full of human dignity, has taken off her mask, scornfully demonstrating

that she does not belong to the "masquerade of life". Very soon Samoilova went abroad again. Neither she nor Briullov knew then that they were parting forever. In a rather sad state of mind Briullov returned voraciously to work. He turned more and more to intimate, psychological por-

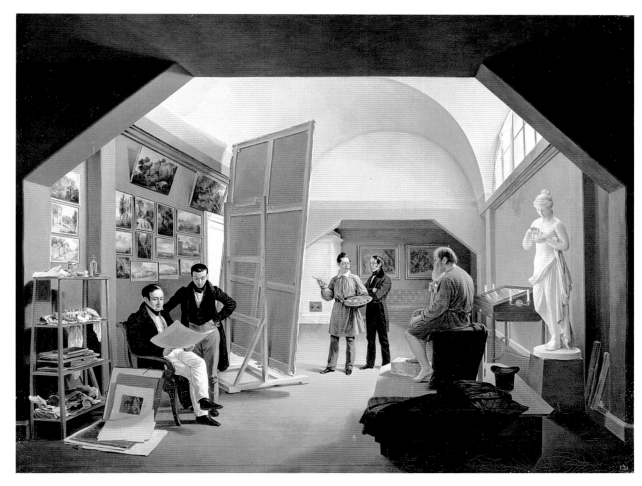

traiture. He created several brilliant portraits, the models for which were the fabulist Ivan Krylov, the poet and translator Alexander Strugovshchikov, the Decembrist Count V. Musin-Pushkin, the sculptor Piotr Klodt's wife Yuliania, the philosopher Konstantin Kavelin and many others. Thus Briullov created a veritable gallery of his contemporaries. Looking at these paintings we can judge how the Russian intelligentsia of the period looked and we can feel their spiritual life and inner world. An interesting paradox: Briullov dreamed of creating a large-scale canvas from Russian history. He failed to do so. He did not suspect that the portraits he created — taken all together — would become a sort of historical gallery, a picture of Russian life at the end of the 1830s and beginning of the 1840s.

The sharp differences between Briullov's commissioned compositional portraits and his psychological likenesses became ever more evident. The commissioned works, including

Portrait of Maria Beck, *Portrait of Prince Alexander Golitsyn* and *Portrait of Count Paskevich-Erivansky*, lacked cordiality, warmth and genuine humanity. It is completely evident that the people portrayed held no interest for the artist. They all have one common quality — everything, down to the tiniest detail, is thoroughly executed with equal veracity, without distinguishing the primary from the secondary. It seemed

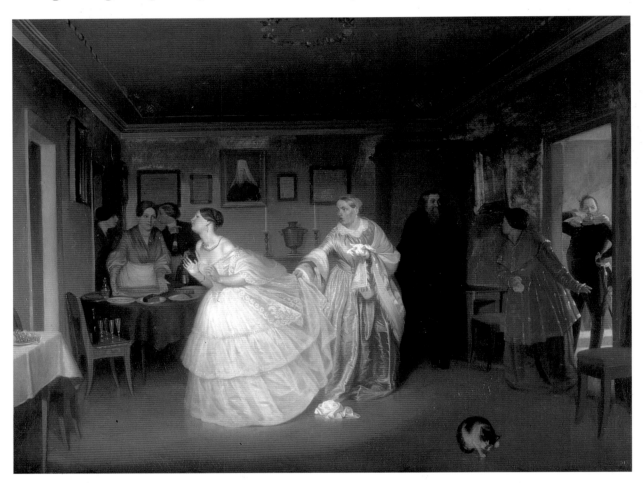

that the artist did all of them only with his virtuoso hand and expert eye, never seeking to penetrate into the characters of those people — they held no appeal for him.

In 1843 his dream of a monumental painting suddenly came true. Together with Fiodor Bruni, Alexei Markov, Piotr Basin, Vasily Shebuyev and Timofei Neff he was invited to create the interior paintings for St Isaac's Cathedral, the main cathedral of St Petersburg, then nearing completion. Briullov's task was to paint the most important murals: the interior of the dome, the figures of the four Evangelists, the twelve Apostles and four large-scale compositions on New Testament themes. He worked under inconceivable strain: not only preparatory sketches for the compositions but every portrait of every model that he used was changed dozens of times, varying one detail or another. It is

Pavel Fedotov
THE MAJOR'S MARRIAGE PROPOSAL
C. 1851

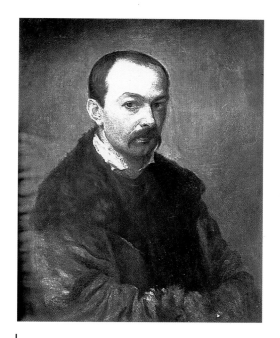

Pavel Fedotov (?)
SELF-PORTRAIT

interesting to note that the images of the Evangelists and Apostles in some of the sketches remind the viewer more of simple Russian peasants than do the soldiers in his historical painting *The Siege of Pskov*. Only after more than two years of preparatory work did Briullov allow himself to actually start painting inside the cathedral.

He began from the dome. The conditions were very hard — it was cold and damp, and constant draughts swept the space. On top of that, the glass frames separating the dome from the interior of the cathedral where the workers were polishing marble and granite, did not protect the artist, forcing him to breathe the dust from below for many hours every day. As a result, in October 1847 Briullov again fell ill. His illness lasted seven months. The doctors did not promise a speedy recovery. All visitors were forbidden. Enforced seclusion and inactivity led Briullov to deep internal meditations. His recent years had been ones of disappointments, failures and losses which weighed heavily on his heart. The failure of *The Siege of Pskov*, the dashed hopes for a happy family life... In 1844 the "brotherhood" had become dispersed: Glinka went abroad for some years, and soon Krylov, with whom Briullov had become quite close when painting his portrait, died. Only recently Venetsianov, the one artist with whom Briullov had felt a communion of ideas, had tragically passed away. Yulia Samoilova had left his life forever. In 1847 Taras Shevchenko was arrested and exiled. Briullov's sense of loneliness and alienation grew ever more acute. But the most serious development was his loss of confidence in his own limitless power — he began to realize that the peak of his creative career was behind him.

Briullov saw excellent works by his former pupils: illustrations by Alexander Agin for Gogol's *Dead Souls*, which were full of the uncompromising truth of life, as well as Grigory Gagarin's illustrations for Vladimir Sollogub's story *The Carriage*. But he was especially impressed by the talented works of another pupil, Pavel Fedotov, which showed that a novel trend in Russian art, after first evolving in graphics, had found its way into painting as well. When the retired captain Fedotov sent him his latest small-scale works, *The Capricious Bride* and *Newly Decorated*, Briullov suddenly realized, with pain, that he was outside of the main trends developing in Russian art. He so much admired the novelty of the little canvases that he immediately sent for their creator. Later Fedotov wrote that he had found his teacher in a "disastrous state" — emaciated, as if dried out, and gloomy, sitting in a leather armchair,

gazing at the pictures. Breaking a prolonged silence, Briullov said: "Your paintings brought me a great delight and therefore a great relief... I congratulate you, I always expected a great deal from you, but you have gone ahead of me..."[1] After Fedotov's departure, Briullov was still in a mood of bitter meditation about his work and the evolution of Russian culture. He realized that Russian literature had also traced out a new, more realistic course. He knew and liked Gogol. He subscribed to a number of journals, and, being fond of reading, he could hardly avoid being aware of the emergence of a great new writer: Fiodor Dostoyevsky, whose novels of poor people, *The Double*, and *The Weak Heart*, had recently been published. And as for painting, Briullov, who used to be ranked first among all Russian artists, realized that he was no longer the best.

Briullov's burdensome thoughts, his split spirit found a striking reflection in his self-portrait of 1848, the profoundest portrayal of a man in Briullov's creative legacy and in Russian painting of the 1830s and 1840s generally. The first thing to strike one in this portrait is the sense of inactivity. Without strength he rests his head on the chair back; his hand with disturbingly protruding blue veins droops from the armrest. But his outward appearance is deceiving. The artist's eyes appear to burn with a kind of fever, his lips are slightly parted as if his inner tension will not allow him to breathe evenly and calmly. His eyebrows are tightly drawn together as though he is unable to rid himself of a painful thought. Yet this thoughtful expression is so energetic, so vivid that the immobility itself seems to suggest activity.

These features of a complex personality also characterized the portrait of Strugovshchikov, but there Briullov found a sharper, fuller artistic solution. The Strugovshchikov portrait is done in a virtuoso style. At that time it was rare for an artist to bring out the inner life of a character through simple, outward material traits, through "corporeity", to use Ilya Repin's word. It seems that Briullov had completely forgotten about local colours, about the usual precepts of chromatic treatment in this simple and natural composition.

As soon as he had partially regained his health, Briullov decided to go abroad. On 27 April 1849, he again left his homeland — this time for good. His route lay through Belgium, England and Portugal to the island of Madeira in the Atlantic. In Belgium and England, Briullov was able to convince himself that he was still a famous artist. In both countries rumours of his arrival quickly reached the local

Karl Briullov
PORTRAIT OF COUNTESS YULIA SAMOILOVA WITH HER ADOPTED DAUGHTER AMICILIA PACINI (MASQUERADE)
Not later than 1842. Detail

[1] Ibid., p. 129.

64

artists and they eagerly came to greet him. Afterwards he visited the studios of some of his true admirers. Since the triumphal progress of *The Last Day of Pompeii* from Italy to Paris and on to Russia nearly two decades had elapsed. On his arrival in Lisbon he painted a portrait of the Russian envoy there, Sergei Lomonosov, who had met the

artist with great sympathy and Russian hospitality. It took five days by sea to reach Madeira from Lisbon. Briullov was enchanted by the beauty of the landscape around the island's capital, Funchal. Surrounded on all sides by blue water, embraced by the light blue vault of the sky, the city was ensconced in flowers and greenery. At that time the air of Madeira was considered to have curative powers.

Briullov met many Russians, who, like himself, had come there with the hope of recovering their health. Staying on Madeira was Maximilian, the Grand Duke of Leuchtenberg, with his retinue. Briullov knew the Grand Duke from the days when Leuchtenberg had held the post of president of

the St Petersburg Academy of Arts after the death of Olenin. The Grand Duke, Princess Anna Bagration, A. Abaza, and Prince A. Meshchersky all sat for portraits by Briullov. Perfectly painted, all the canvases were unmistakably recognizable as Briullov's works, but they were evidently the product of a tired hand. Nevertheless, after sending his portraits of Bagration and the Grand Duke to St Petersburg, Briullov received laudatory comments in the press. Of much greater interest, however, are the watercolour compositions done in Madeira: *Promenade, View of the Island of Madeira*, and a dual portrait of the Mussards, husband and wife, members of the Grand Duke's suite. This last work, quite large in size, shows the couple on horseback. The composition, colour scheme and linear design are carefully

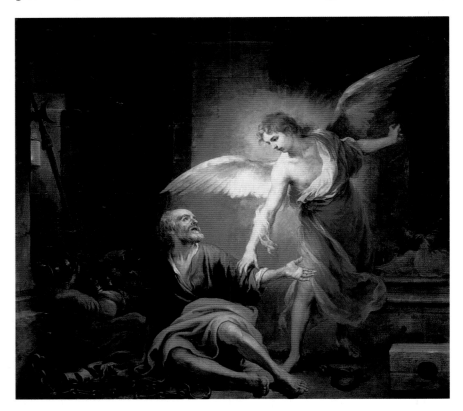

thought out, but the detailed finish is so delicate that it does not spoil an impression of a monumental piece. This is a "portrait-painting" in the fullest sense. As is often the case with Briullov, the work is pervaded with a sense of turbulent motion: the riders are barely able to restrain their mounts, that are prancing, impatiently awaiting the command to gallop. The artist openly admires the youthful riders, the grace with which they sit in the saddles and the well-bred lines of their horses. Doomed by his disease to immobility, Briullov found an especial pleasure in emphasizing boisterous movement, beauty and flourishing youth. A year slipped by unnoticed under the curative rays of the

Bartholomé Esteban Murillo
THE LIBERATION OF THE APOSTLE PETER FROM THE DUNGEON
1667–70

subtropical sun. Briullov regained his strength to such an extent that he risked a trip alone through Spain. He had a very practical reason for that journey. He suffered from an aneurism of the heart, which was then considered a very dangerous condition. Briullov had been told that a famous healer living in Barcelona could cure him or at least alleviate his sufferings. The journey through Spain turned out to be fruitful for his creative endeavours as well. He saw many paintings of the Spanish school, including the works of his favourite artist Velázquez, and he became acquainted for the first time with Murillo. The influence of Goya can also be felt in Briullov's work in his last two years In the suburbs of Madrid, in the Church of San Antonio, he may have seen the strikingly expressive murals by Goya. He may also have visited Goya's house, where the great Spanish artist's works could be viewed. Whatever the case, Briullov's last pictures reveal some features reminiscent of Goya's art — his civic stand, acute sense of the times and deep popular spirit.

Briullov seems to have been attracted by Goya's manner of painting too, especially by the textures — wide brushstrokes with light glazings, which did not conceal the rough surface of the paint. Many of the Spaniard's great works, such as the *Capriccios* series or the painting *Spain. Time. History*, were allegorical in tone. The use of allegory, not unknown in the earlier Briullov, became increasingly attractive for him in his final years. After Spain, Briullov travelled to Italy. In less than two years spent living in Rome, despite continuing ill health, he created many beautiful works. Without any doubt it can be said that many of them revealed a new Briullov, one who promised a more mature, deeper, more truthful art without overly beautifying nature. There are several reasons for that: almost always a long illness or suffering endured by an artist yields a new sort of vision, a clearer and greater wisdom. The works of the Spanish master Goya too had stirred Briullov's thoughts, his soul and his imagination.

The artist's surroundings in his last period also created a specific environment. At first he often met members of the Russian colony living in Rome, his former pupils Fiodor Moller and Grigory Mikhailov among them. After a long separation he also renewed his acquaintance, to their mutual delight, with Princess Zinaida Volkonskaya. Very soon, however, most of the Russians left Italy, but fate brought Briullov, as a sort of substitute, a friendship with Angelo Tittoni, a companion-in-arms of Garibaldi. Even now Tittoni's bust can be seen in the Alley of Heroes, on

Gianicolo Hill in Rome. He was Colonel of the Revolutionary National Guards, spending nearly all of 1847 as a prisoner in Castel Sant'Angelo. In Tittoni Briullov found a devoted friend for the declining years of his life. His brothers Antonio, Mariano, Vincenzo and their mother Catarina (or Nina Tittoni as she was known) received the sick Russian artist as though he was one of the family. Now Briullov, in the winter, lived at their home in the Via del Corso and in the spring and summer moved with them to their villa in Manziano. His daily communication with heroes of the Italian liberation movement could not but affect his political ideas.

Briullov painted almost all members of the Tittoni family, including even Mariano's wife and children. His likenesses of Angelo and Catarina are especially remarkable for their insight into character. In the image of Angelo he emphasized such dominant qualities as energy, powerful spiritual strength and unbending will. Briullov thought of his new friend as a contemporary Brutus, even giving his figure the same pose as Michelangelo gave Brutus in his work. The portrait of Catarina Tittoni radiates softness, wisdom and the slight gloom of old age — yet behind her feminine features one can feel will and courage, without which she would not have been able to endure the lot of a mother of heroic sons living in an atmosphere of constant danger. Briullov gave an even more heroic interpretation to the image of Giulietta, Angelo's daughter, depicting the girl in armour, with a horse, like some nineteenth-century Italian Joan of Arc.

It was of course Angelo Tittoni who told Briullov of recent events in Italy and the hopes aroused in Italians when Pope Pius IX ascended the papal throne. In his speech, delivered from the balcony of the Palazzo Quirinale on 18 June 1846, before throngs of people, the new pope swore that amnesty would be granted to all of the participants in the liberation movement and promised to give Rome a new municipal structure. The people believed that now the pope himself would become the leader of the movement against Austrian domination and for the unification of Italy. In answer to the pope's promises there was a joyful and spontaneous political demonstration. Briullov chose that very event as the subject for a new painting but he did not have the strength to complete the work. Three sketches, though very expressive, are all that remain of that unfinished undertaking. They bear witness to the emergence of a new manner in Briullov's art.

The novel features are seen even better in his next work —

Karl Briullov
*PORTRAIT OF GIULETTA TITTONI
IN ARMOUR*
1851–52

Girl in a Forest. A young girl from Albano is depicted, sitting in a small, sunlit clearing in the midst of a dense forest. Many times in his career Briullov had attempted to solve the problems posed by painting in open air. And though this work also was never completed, he did accomplish that goal in this painting, done at the end of his life. The subject is very simple, there is nothing unexpected,

and perhaps that is why the unusual technical devices immediately attract one's attention. In that small canvas Briullov, in an amazingly truthful and natural way, solved the problems of colour and light. Every colour is fused with light, giving the feeling of a true air medium created on the canvas. The new kind of texture — transparent glazings covering the wide patches of paint — inevitably reminds us of the fact that not long before Briullov had

Karl Briullov
PORTRAIT OF ANGELO TITTONI
1851–52

become acquainted with Goya's art. This feature is even more pronounced in his painting *The Procession of the Blind in Barcelona*. At first, probably still in Spain, he did a watercolour and then reproduced the scene, which had impressed him so much, on paper in oils. Not only the method of applying paint reminds us of Goya. Looking at *The Procession of the Blind in Barcelona* one recollects Spanish traditional processions interpreted by Goya in his works *Funeral of the Sardine* and *The Procession of the Flagellants*. But the resemblance was not only in the subjects. Certainly compared to the tragic and grotesque procession of fanatics, torturing themselves, the blind beggars portrayed by Briullov appear more static and quiet. But if one remembers Briullov's genre scenes of previous years, one recognizes that in this work the artist showed the drama of contemporary life, something he had never done before. The underlying feeling of isolation was strengthened by the depiction of armed guards on both sides of the procession, while in front of the beggars are two horsemen wearing three-cornered hats, carrying drums and announcing the procession to those ahead.

Goya, being a profoundly national painter, captured with striking force and veracity the customs, character and the depth of the spiritual essence of his people. The Russian artist, although a foreigner, could with the intuition of a great master, still catch something which was distinctive in the people, scenery and soil of Spain.

The above description of late trends in Briullov's creative work is not by any means exhaustive. He reached the highest peak of artistic understanding of the world, looked at life with clean and open eyes, and was now not affected by the rigid canons of tradition. Briullov's new vision led him to different principles of creation, which might be exemplified by his series of sepia works *Lazzaroni on the Seashore*. Sitting with his sketchbook somewhere on the beach he watched, for hours, the slow, lazy life of those beggars. A young mother is dozing on the steps, her naked baby has fallen asleep, but she has left her breast uncovered. Above them is the father, half standing, half leaning with his leg on the parapet. It seems that he has been holding that pose, idly watching the movement of the light clouds, for centuries. In the entire sepia series there is not a single sheet in which the artist reveals a desire to return to classical images. He completely devoted himself to nature, seeking and looking for original gestures, faces and characters. At the finish of his life Briullov took the first steps on the path of true realist art. Indeed, how painful it is to realize

that in taking that road upward he had only a few days left. It is really quite natural that in the field of portraiture, Briullov scaled high peaks. Such works as *Head of an Abbot* and the portrait of the archaeologist Michelangelo Lanci belong to the same class as his self-portrait of 1848

and perhaps even surpass it. When Briullov portrayed Lanci, the latter was seventy-two years old. The artist did not conceal the signs of age, and bodily decay. Briullov seems to say to the viewer: scrutinize the features of this old man, who has lived a long and complicated life; he is not too tired to live, he has not lost his youthful interest in life. His penetrating eyes stare perceptively out at us. Many contemporaries, the eminent critic Vissarion Belinsky among them, said that in his best portraits Briullov painted not the eyes but something which is very difficult to depict — the gaze of a person. Lanci looks as though he is awaiting rather than asking — as if he had just expressed a compli-

Francisco Goya
THE FUNERAL OF THE SARDINE
C. 1800

73

cated idea and expects us to react. Thus the artist makes his character a partner in a dialogue with the viewer, showing the active intellectual atmosphere that surrounded the old man. To fulfil that task, the artist chose a very good gesture — Lanci's hand, holding his pince-nez, is suspended in an unstable position, while we, submitting to the artist's will, believe that only a second before Lanci took off his glasses and lowered his arm.

The portrait was brilliantly painted, its colour scheme based on a complicated balance but at the same time not lacking in decorative beauty. By the subtlest gradations, by the introduction of warm shades into the generally cold palette Briullov created a real human image. For the costume the artist chose a complicated blend of yellow and red tones with bluish violet ones. If Briullov had not used some greyish shades for the folds of the robe, the massive unbroken area of red would have ruined the colour integrity of his canvas. To bolster that integrity, Briullov introduced a play of silvery glints in the perfectly finished fur collar.

Towards the end of his life in Italy Briullov continued to plan his return to Russia, but the painful attacks of illness were occurring with ever greater frequency. Now he worked in defiance of his doctor's advice, overcoming horrendous pain, ignoring the urgings of his friends. To all of Tittoni's pleas he replied: "Leave me to draw; when I'm not working on compositions, not drawing, I'm not living."[1]

He was in a hurry, with premonitions that very little time remained for him. His soul also was troubled by the notion that in his short life he had not fulfilled even half of what he had planned. He still had many intentions yet the thought of his approaching death did not frighten him. He spoke quietly on the subject with his friends, asking them to bury him in the Cemetery of Monte Testaccio. (He even depicted a winged Diana flying over that cemetery.) Most of his last works were filled with sorrow, while some were dramatic, even verging on tragedy — such as, *A Flying Angel Mourning the Victims of the Inquisition*. Briullov probably did this sketch based upon his memories of Spain. The profoundest undertaking was his drawing *All-Destroying Time*. The idea of Time, so rapidly passing and all-powerful over human destiny, had long fascinated him. Among his earlier sketches there was one which depicted Cronus, the Graces, Cupid, and the Poet. That sketch was done in 1837, when Briullov together with all of Russia, was mourning the death of Pushkin. The essence of that work was tragic. In his conception Cronus-Saturn was inexorably merciless. An old man, symbolizing time and somehow suggesting the famous statue of Moses by

Karl Briullov
PORTRAIT OF MICHELANGELO LANCI
1851
Oil on canvas. 61.8 x 49.5 cm
Tretyakov Gallery, Moscow
Michelangelo Lanci (1779-1867),
Italian archaeologist and orientalist

[1] *K. P. Briullov in Letters...*, p. 225.

74

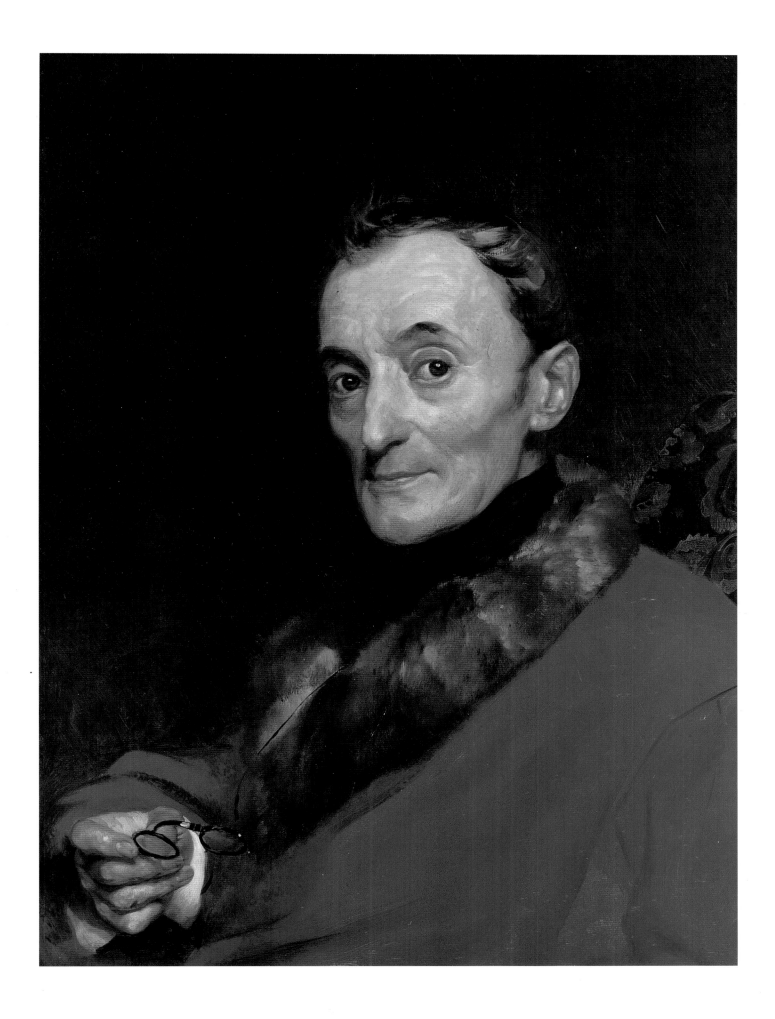

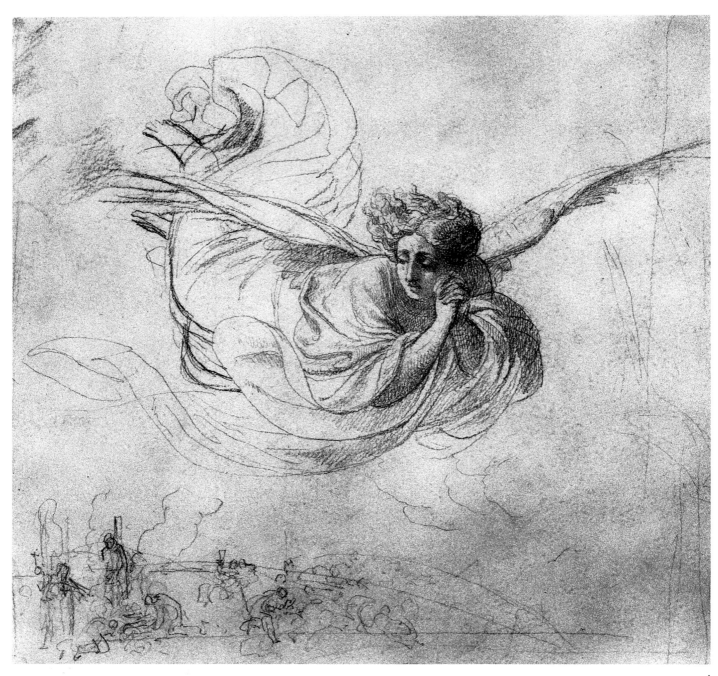

Michelangelo, occupies the entire upper part of the composition. At the will of Time, as the critic Vladimir Stasov wrote, "the waterfall of people" rushes onwards into the river of oblivion. All types of religion — Judaism, Christianity and Islam are there; lawmakers: Solon, Lycurgus; poets and scientists: Homer, Dante, Petrarch, Ptolemy, Newton, Copernicus, Galileo; Egypt and Greece are shown falling down; Jan Hus and Martin Luther; strength and power; love and beauty. The images of the embracing figures embody the last parting of Anthony and Cleopatra. In the very centre there is a female figure being strangled by another figure — everyone is equal before the senseless, merciless Cronus. All of these figures were followed by

Karl Briullov
*A FLYING ANGEL MOURNING
THE VICTIMS OF INQUISITION*
1849–50
Lead pencil on paper.
23.2 x 25 cm
Russan Museum, St Petersburg

76

Karl Briullov
CHRIST IN MAJESTY
1843–47. Sketch for a ceiling
painting in St Isaac's Cathedral
Oil on canvas.
Tondo, diameter 65 cm
Russian Museum, St Petersburg

[1] *K. P. Briullov in Letters...*, p. 237.

commanders and powerful rulers: Alexander the Great, Nero, Napoleon, and at the bottom of the canvas Briullov was going to insert himself.

In the spring of 1852 Briullov moved with the Tittoni family to Manziana outside Rome. On the morning of 23 June 1852, he felt well and even smoked a cigar after lunch. Suddenly he was overcome by an uncontrollable coughing fit; blood came from his mouth and Briullov realized that this was the end. He met it with courage. During his declining years he used to say that as he had lived lavishly, he could not last more than forty years — and then added: "Instead of forty I've lived fifty, therefore I stole ten years from eternity. So I have no right to complain about my lot."[1]

The coffin containing Briullov's body was transferred to

Rome. The artist's admirers met the coffin outside the city and carried it on their shoulders to Monte Testaccio. His remains are still there.

Neither Briullov's creations, nor his name have been forgotten. His highly individual personality influenced many Russian artists. Two years before Briullov's death the young Nikolai Gay arrived to enter the Faculty of Mathematics at the University in St Petersburg. There he saw *The Last Day of Pompeii* and was unable to tear himself away from it. The power of the painting was so great that it changed the destiny of that young man. Science lost its future servant but art acquired a great talent.

Ilya Repin, as a boy of eight years old — 1,500 miles from the Russian capital — dreamed of becoming an artist. He knew the name of Briullov and the legends about his art. Throughout his entire life Repin carried this feeling of worship for Briullov, calling him a "virtuoso", a "giant" and comparing him with Raphael.[1]

The fire lit by Karl Briullov was not extinguished with his death. In every new generation there has been an artist who took up that torch and carefully carried it on, before passing it to the next deserving heir.

Galina Leontyeva

Karl Briullov
THE EVANGELIST LUKE
1843–47. Study for a pendentive painting in St Isaac's Cathedral
Sepia and black chalk, heightened with white, on paper. 44 x 55 cm
Tretyakov Gallery, Moscow

[1] I. Ye. Repin, *Far and Near*, Leningrad, 1982, p. 412 (in Russian)

PAINTING
GRAPHIC ART

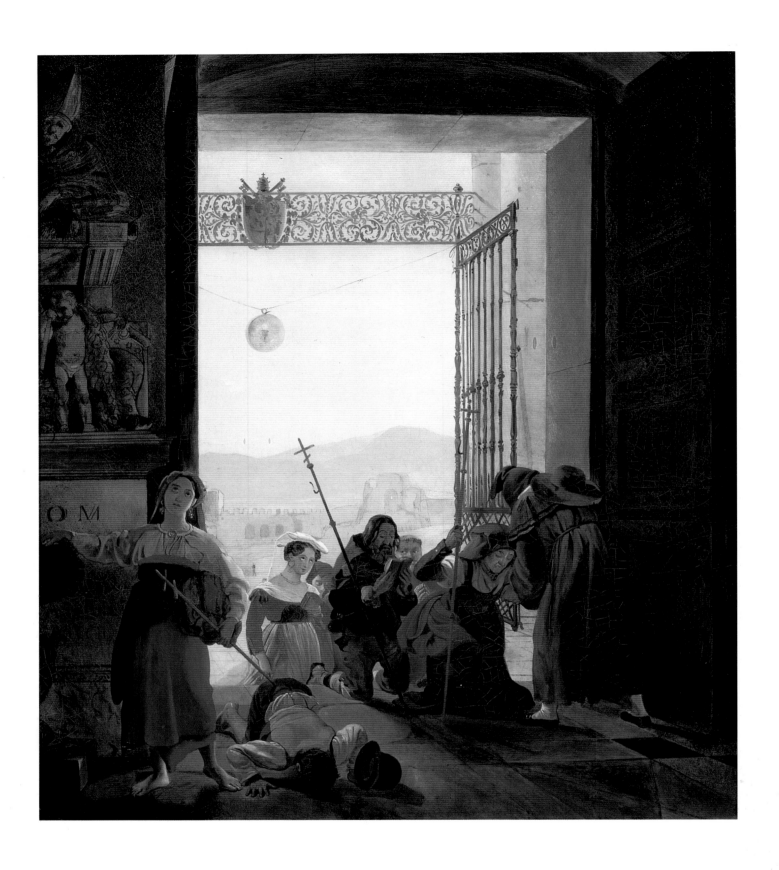

1. _PILGRIMS IN THE DOORWAY_
OF THE LATERAN BASILICA
1825
Oil on canvas. 62.7 x 53.6 cm
Tretyakov Gallery, Moscow

2

2. *PILGRIMS
IN THE DOORWAY OF A CHURCH*
1825. Variant of the 1825 painting
*Pilgrims in the Doorway of
the Lateran Basilica* (now in
the Tretyakov Gallery, Moscow)
Oil on paper. 20.4 x 16.2 cm
Russian Museum, St Petersburg

3. *NUMA POMPILIUS AND
THE NYMPH EGERA*
1834. Sketch
Oil on paper. 28.5 x 36 cm
Tretyakov Gallery, Moscow

3

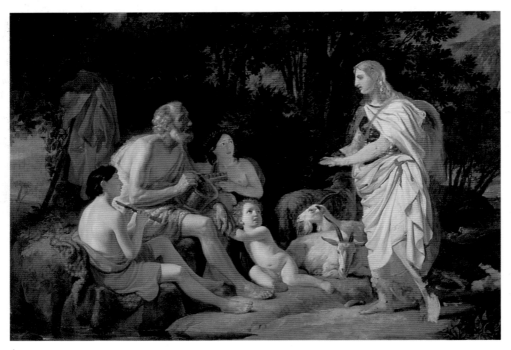

4

4. *ERMINIA WITH THE SHEPHERDS*
1824. Inspired by Torquato Tasso's
Jerusalem Delivered. Unfinished
Oil on canvas. 98.2 x 137.3 cm
Tretyakov Gallery, Moscow

5

5. _HYLAS AND NYMPHS_
1827. Sketch for an unrealized
painting
Oil on canvas. 22.4 x 27.5 cm
Art Museum, Kirov

6

6. *PORTRAIT OF ANNA SCHWARZ*
1833–35
Watercolour on cardboard.
21.3 x 16.5 cm
Russian Museum, St Petersburg

7

7. *PORTRAIT OF MARIA KIKINA*
1821–22

Oil on canvas. 82.6 x 71.7 cm
Tretyakov Gallery, Moscow

Maria Arnoldovna Kikina (1787–1820s),
née Torsukova, wife of Piotr Kikin, one
of the founders of the Society for
the Encouragement of Artists

8. *PORTRAIT OF
KIRILL AND MARIA NARYSHKIN*
1827
Watercolour on paper.
44.1 x 35.4 cm
Russian Museum, St Petersburg

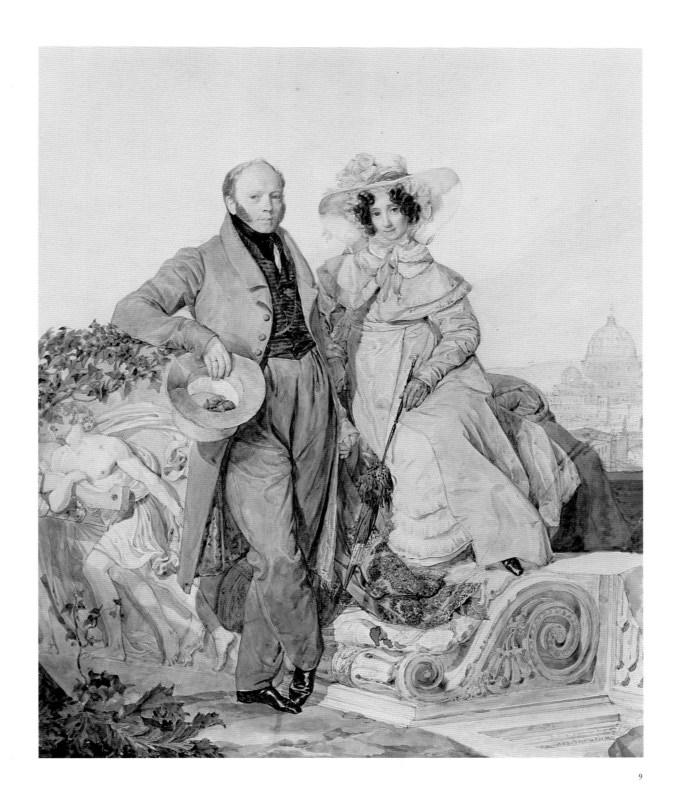

9

9. *PORTRAIT OF*
GRIGORY AND VARVARA OLENIN
1827

Watercolour and lead pencil
on paper. 42.5 x 33.5 cm
Tretyakov Gallery, Moscow

Grigory Nikanorovich Olenin (1797–1843).
Varvara Alexeyevna Olenina (1802–1877),
his wife, daughter of Alexei Olenin,
the president of the Academy of Arts

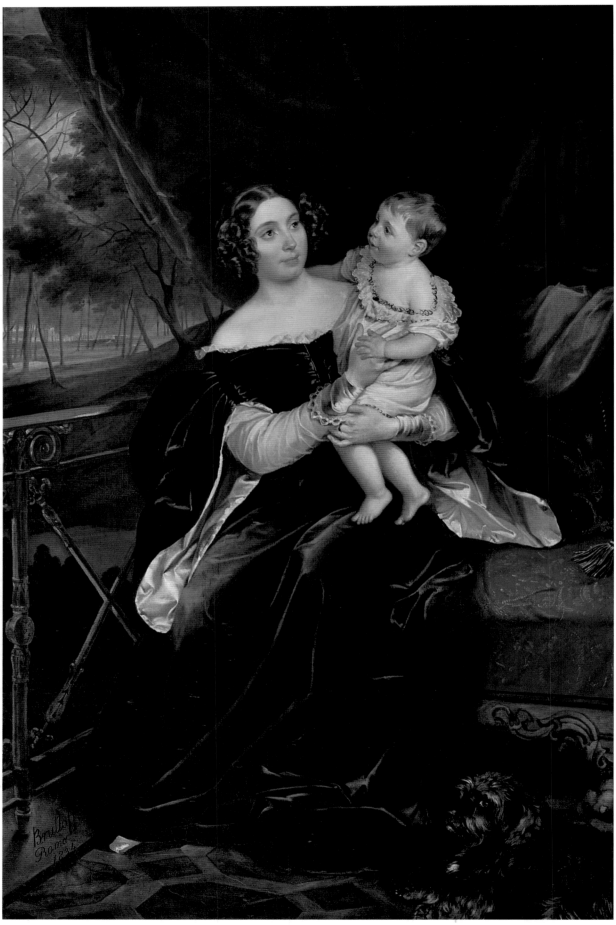

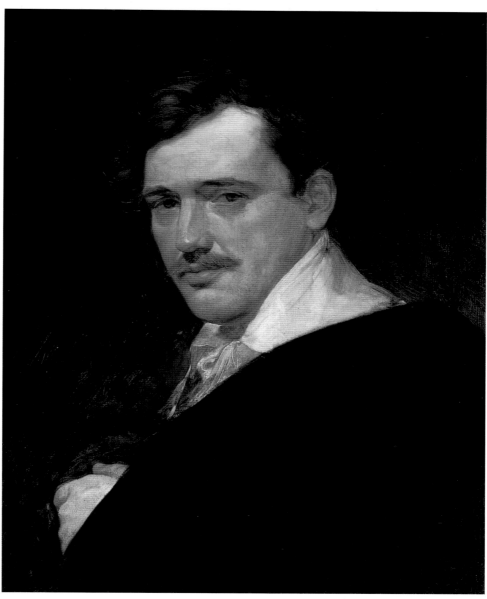

10. *PORTRAIT OF OLGA DAVYDOVA
WITH HER DAUGHTER NATALIA*
1834.
Right-hand part of a Davydov
family portrait

Oil on canvas. 195 x 126 cm
Tretyakov Gallery, Moscow

Olga Ivanovna Davydova (1814–1876),
née Princess Bariatinskaya, wife of
Vladimir Davydov (subsequently, Count
Orlov-Davydov)

11. *PORTRAIT OF ALEXANDER LVOV.*
1824

Oil on canvas. 62.3 x 49.5 cm
Tretyakov Gallery, Moscow

Alexander Nikolayevich Lvov (1786–1849),
architect

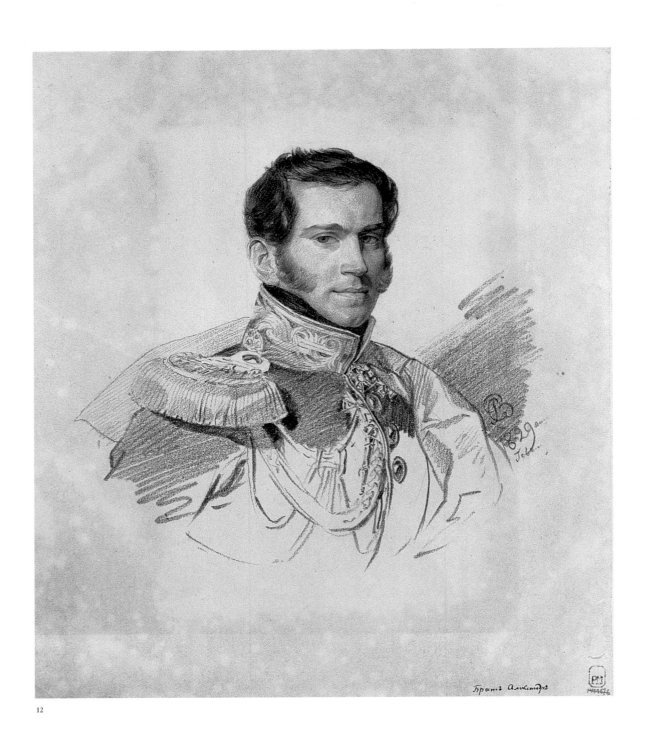

12

12. *PORTRAIT OF*
THE AIDE-DE-CAMP A. FERSEN
1829
Black chalk on paper. 24 x 20.4 cm
Russian Museum, St Petersburg

13. *PORTRAIT OF GRAND DUCHESS*
YELENA PAVLOVNA WITH
HER DAUGHTER
1830
Oil on canvas. 265 x 185 cm
Russian Museum, St Petersburg
Yelena Pavlovna (1806–1873), wife of
Grand Duke Mikhail Pavlovich

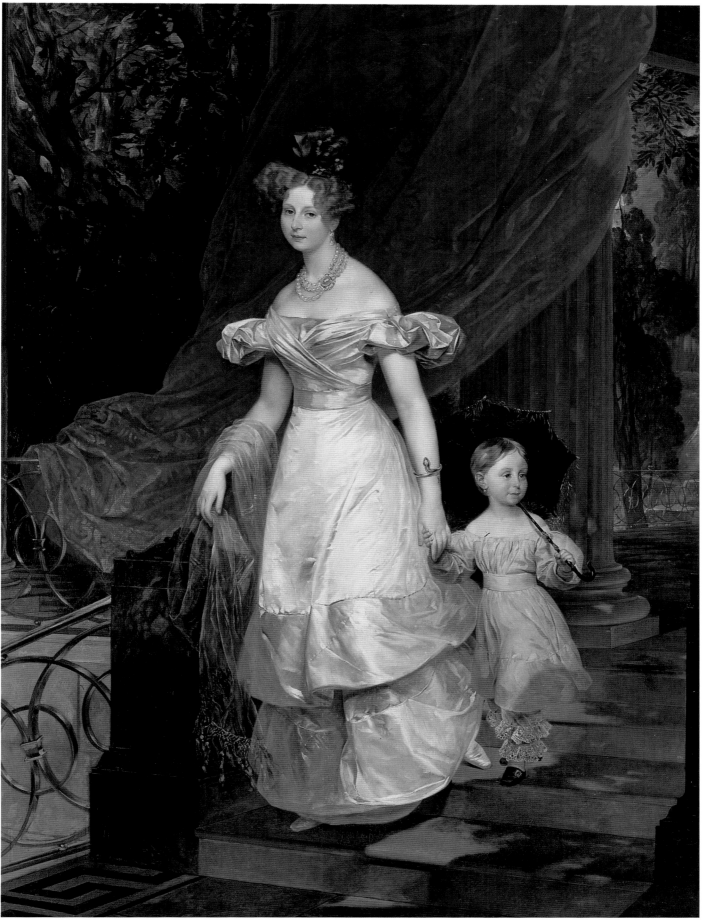

14

14. *SCENE ON THE THRESHOLD OF A CHURCH (THE BLESSING OF CHILDREN IN THE CHURCH OF ST ANNE?)*
1827
Watercolour on paper. 23 x 17 cm
Radishchev Art Museum, Saratov

15. *CONFESSION OF*
AN ITALIAN WOMAN
1827–30
Watercolour on paper. 26.2 x 18.7 cm
Russian Museum, St Petersburg

16

16. *AT THE MADONNA'S OAK*
1835
Oil on canvas. 61 x 74 cm
Tretyakov Gallery, Moscow

17. *MERRY-MAKING IN ALBANO*
1830–33
Watercolour on paper. 20.4 x 16.5 cm
Tretyakov Gallery, Moscow

18. *CELEBRATION OF
THE GRAPE HARVEST*
1827
Watercolour on paper. 16.7 x 22.5 cm
Tretyakov Gallery, Moscow

17

18

19

19. _A Mother Waking Up from Her_
Child's Crying
1831
Sepia on cardboard. 22.5 x 28 cm
Russian Museum, St Petersburg

20. _Bathsheba_
1832
Oil on canvas. 173 x 125.5 cm
Tretyakov Gallery, Moscow

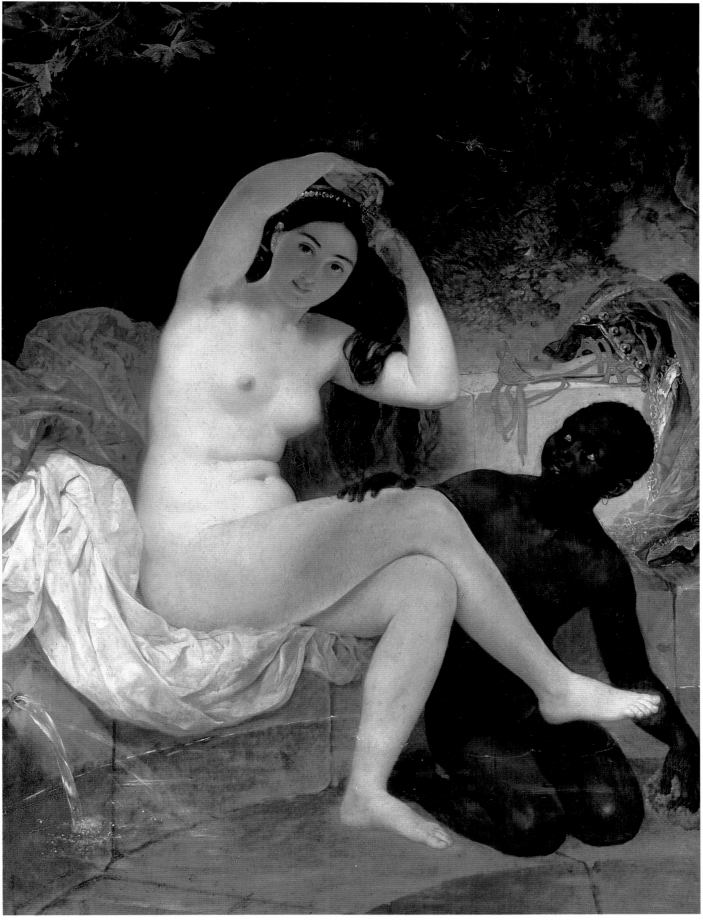

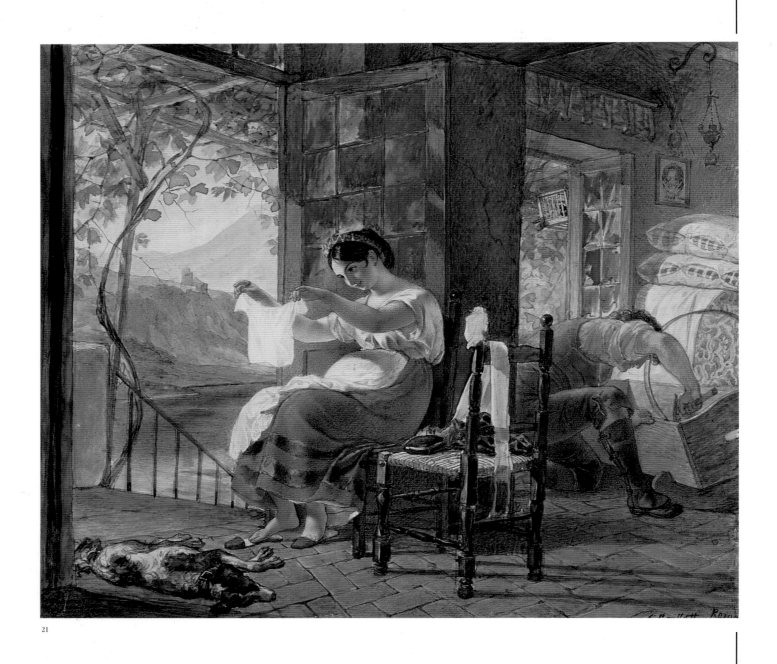

21

21. *AN ITALIAN FAMILY*
1831
Watercolour on cardboard.
18.8 x 22.4 cm
Russian Museum, St Petersburg

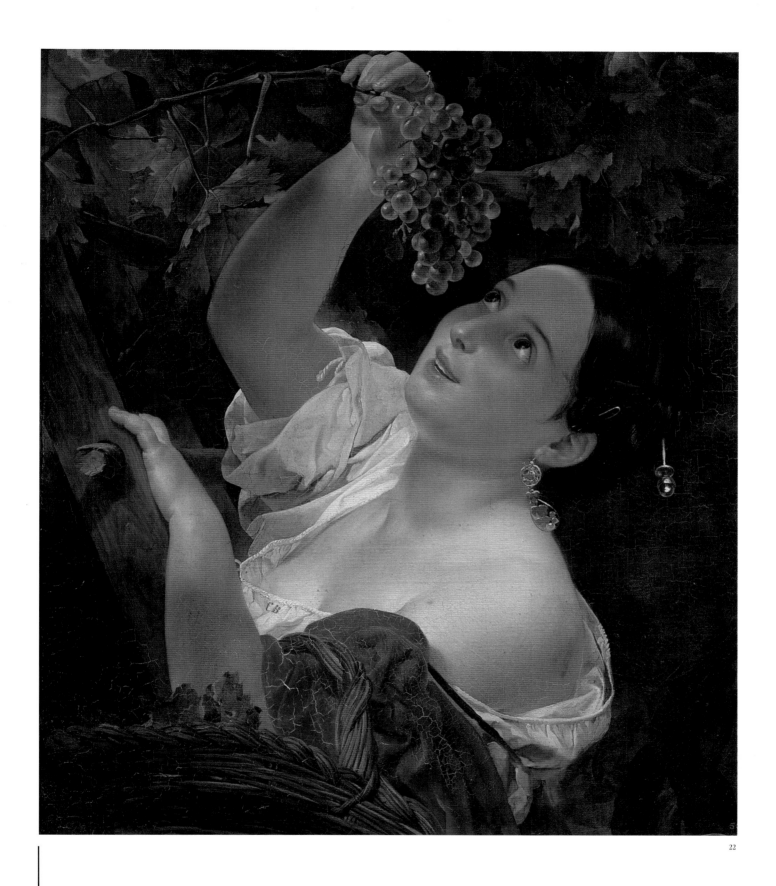

22. *ITALIAN MIDDAY*
1827
Oil on canvas. 64 x 55 cm
Russian Museum, St Petersburg

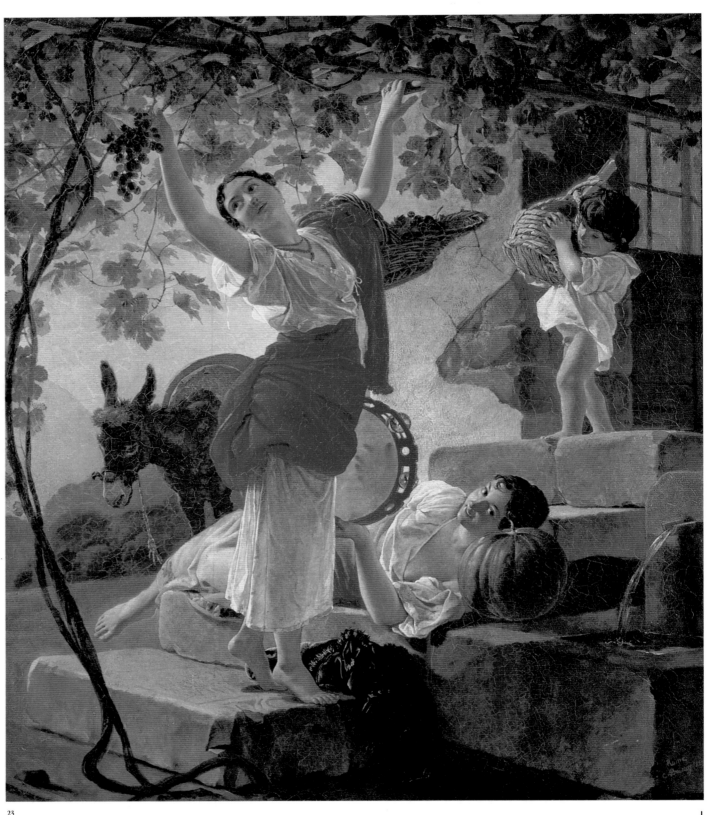

23

23. *YOUNG GIRL GATHERING GRAPES*
 IN THE NEIGHBOURHOOD
 OF NAPLES
1827
Oil on canvas. 62 x 52.5 cm
Russian Museum, St Petersburg

24. *PORTRAIT OF DOMENICO MARINI
(BALL PLAYER)*
1828–30

Oil on canvas. 50 x 62 cm
Museum of History, Art and
Architecture, Novgorod
Domenico Marini, Italian athlete

24

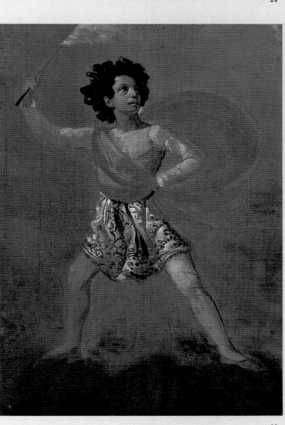

25

25. *VAULTER*
1829

Oil on canvas. 43 x 30 cm
Russian Museum, St Petersburg

26

26. *An Italian Woman Lighting*
a Lamp Before the Image of
the Madonna
1835
Watercolour, lead pencil and Indian
ink on paper. 29 x 19 cm
Tretyakov Gallery, Moscow

27. *Rider. Double Portrait of*
Giovanina and Amazilia Pacini
1832
Oil on canvas. 291.5 x 206 cm
Tretyakov Gallery, Moscow
Giovanina and Amazilia Pacini, adopted
daughters of Countess Yulia Samoilova

28

28. *PORTRAIT OF THE ARTIST AND BARONESS YEKATERINA MELLER-ZAKOMELSKAYA WITH HER DAUGHTER IN A BOAT*
1833–35

Oil on canvas. 151.5 x 190.3 cm
Russian Museum, St Petersburg

Yekaterina Nikolayevna Meller-Zakomelskaya (? – not earlier than 1861), née Shidlovskaya, wife of Ye. Meller-Zakomelsky

29. *PORTRAIT OF FANNI PERSIANI-TACHINARDI AS AMINA IN BELLINI'S OPERA LA SONNABULA*
1834

Oil on canvas. 113 x 87 cm
Museum of the Russian Academy of Arts, St Petersburg

Fanni Persiani-Tachinardi (1812–1867), Italian singer

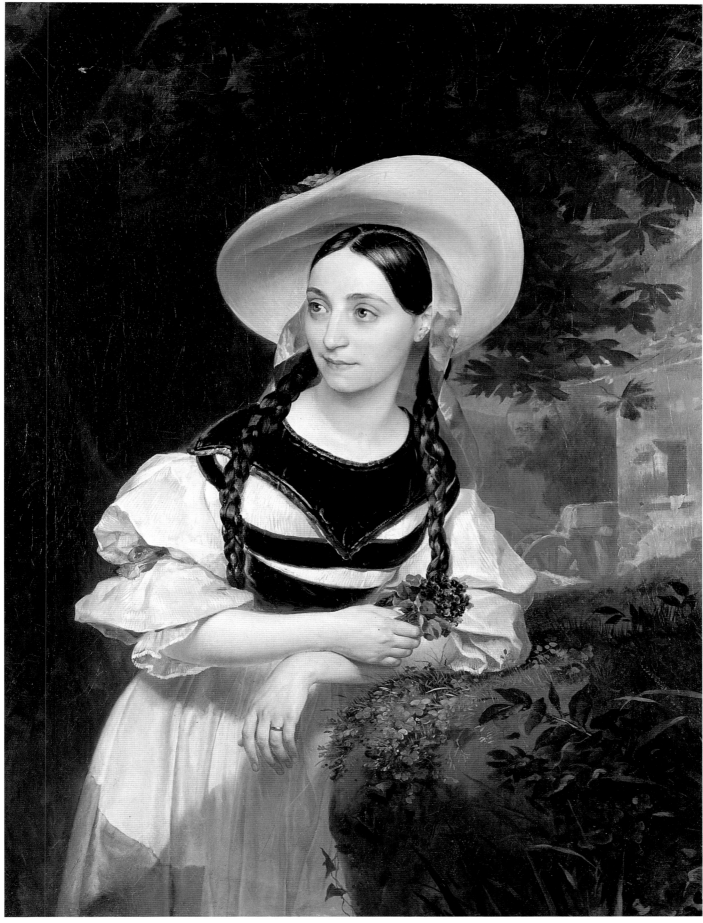

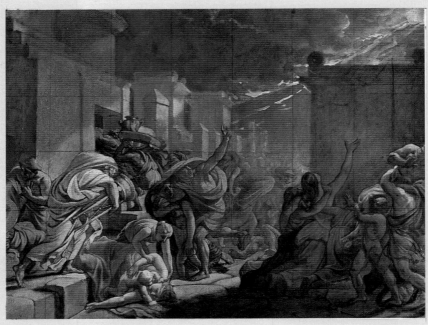

30

30. *THE LAST DAY OF POMPEII*
1827. Sketch for the 1830–33 paint-
ing of the same title (now in the
Russian Museum, St Petersburg)
Oil and black chalk on canvas.
58 x 76 cm
Tretyakov Gallery, Moscow

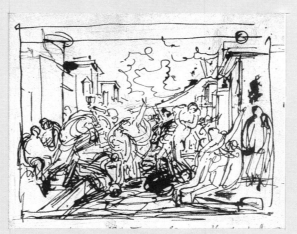

31

31. *THE LAST DAY OF POMPEII*
1829. Sketch for the 1830–33
painting of the same title (now in
the Russian Museum, St Petersburg)
Pen and bistre on paper.
15.5 x 18.9 cm
Tretyakov Gallery, Moscow

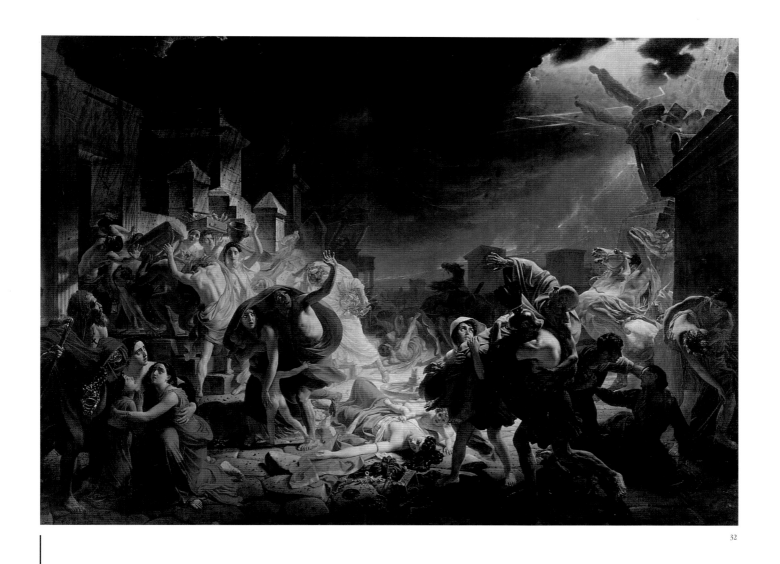

32. *THE LAST DAY OF POMPEII*
1830–33
Oil on canvas. 456.5 x 651 cm
Russian Museum, St Petersburg

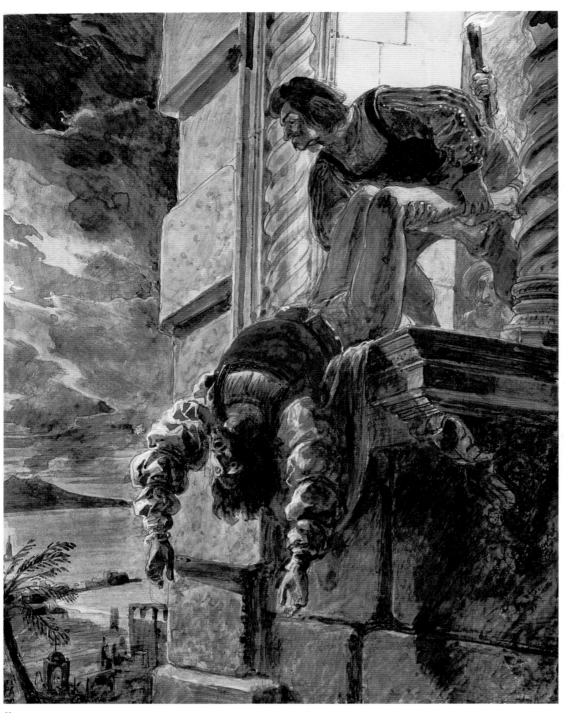

33

33. *THE MURDER OF PRINCE
ANDREW OF HUNGARY BY ORDER
OF GIOVANNA (JOANNA) OF NAPLES*
1835
Watercolour on paper pasted
on cardboard, heightened with
white and varnish.
35.5 x 25.8 cm
Art Museum, Ulyanovsk

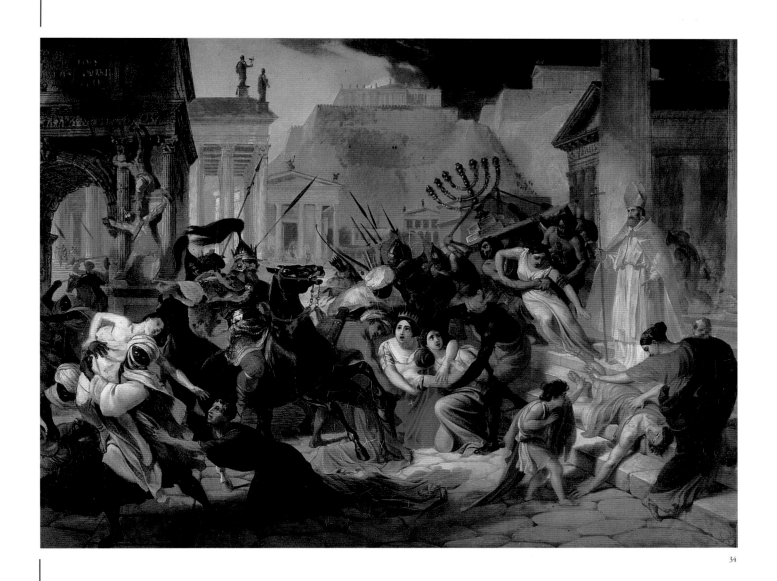

34. *GENSERIC'S INVASION OF ROME*
1833–35. Sketch for an unrealized
painting
Oil on canvas. 88 x 117.9 cm
Tretyakov Gallery, Moscow

35

35. *VIEW OF THE ISLAND OF MADEIRA*
1849
Watercolour on paper. 19.9 x 24.6 cm
Russian Museum, St Petersburg

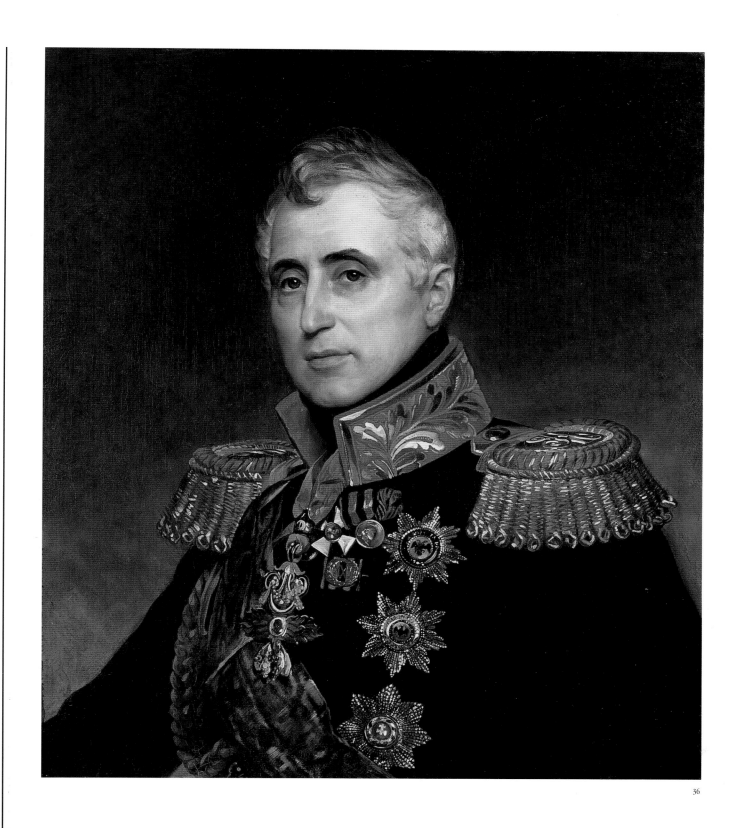

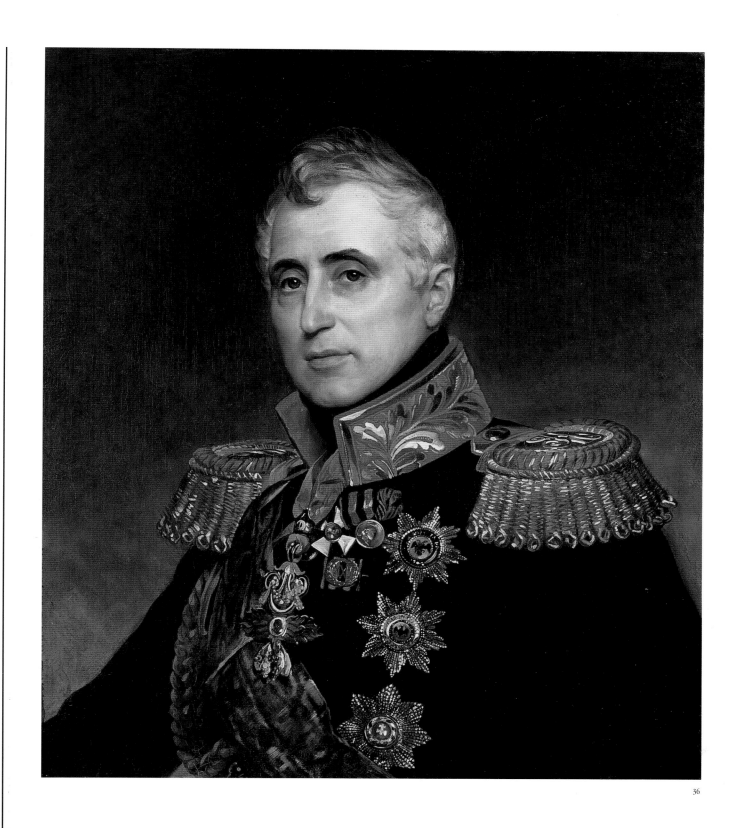

36. *PORTRAIT OF*
COUNT CARLO POZZO DI BORGO
1833–35

Oil on canvas. 71 x 63 cm
Radishchev Art Museum, Saratov

Carlo Pozzo di Borgo (1764–1842),
Count, Russian diplomat, born on Corsica

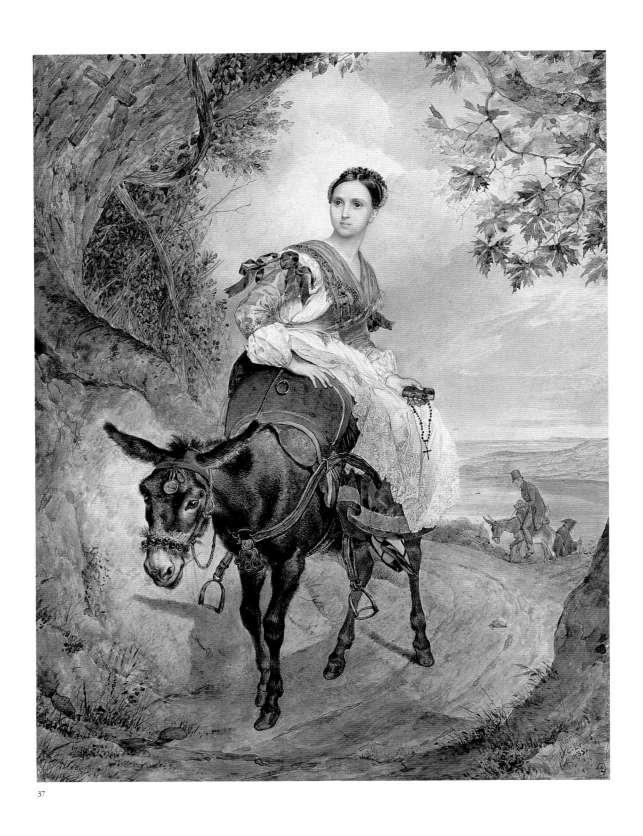

37

37. *PORTRAIT OF COUNTESS OLGA FERSEN RIDING A DONKEY*
1835

Watercolour on paper. 51.5 x 39.6 cm
Russian Museum, St Petersburg

Olga Pavlovna Fersen (1808–1837), née
Countess Stroganova, wife of Count P. Fersen

38

38. *PRINCESS YELIZAVETA SALTYKOVA ON A BALCONY*
1833–35
Watercolour on paper. 44.4 x 33.6 cm
Russian Museum, St Petersburg
Yelizaveta Pavlovna Saltykova, née Countess
Stroganova, wife of Prince I. Saltykov

40

39. *Portrait of Count Matvei Vielgorsky*
1828

Oil on canvas. 138 x 97.5 cm
Art Museum of Byelorussia, Minsk

Matvei Yuryevich Vielgorsky (1794–1869),
musician and composer

40. *Portrait of Yekaterina Semionova*
1836

Oil on canvas. 80 x 59 cm
Bakhrushin Theatre Museum, Moscow

Yekaterina Semionovna Semionova
(1786–1849), Princess Gagarina by marriage,
actress

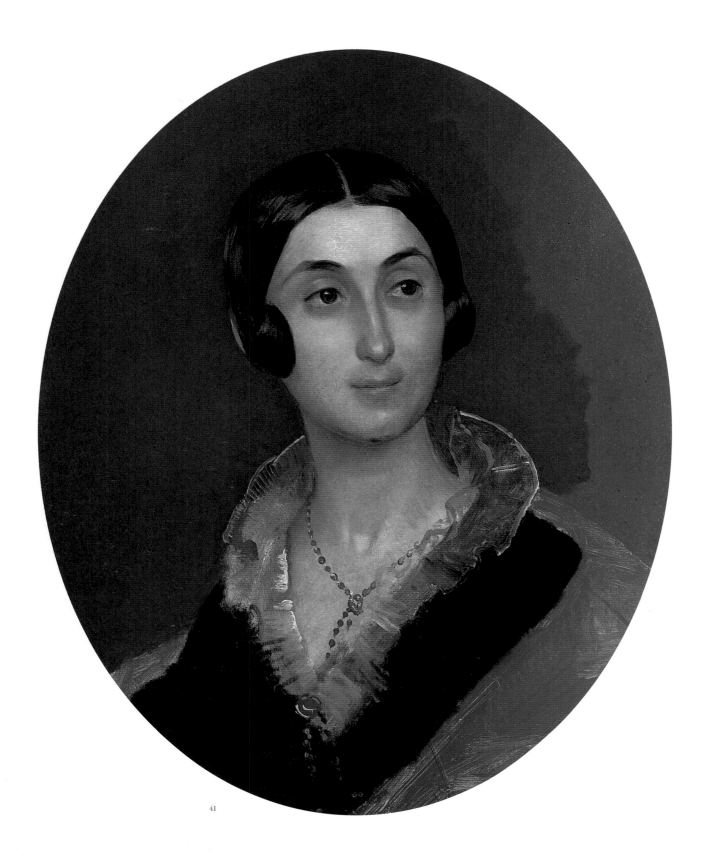

41

41. *PORTRAIT OF YELENA THON*
1837–40
Oil on canvas. 56 x 47 cm
Russian Museum, St Petersburg
Yelena Ivanovna Thon (1821–?), née Berg,
wife of the architect Konstantin Thon

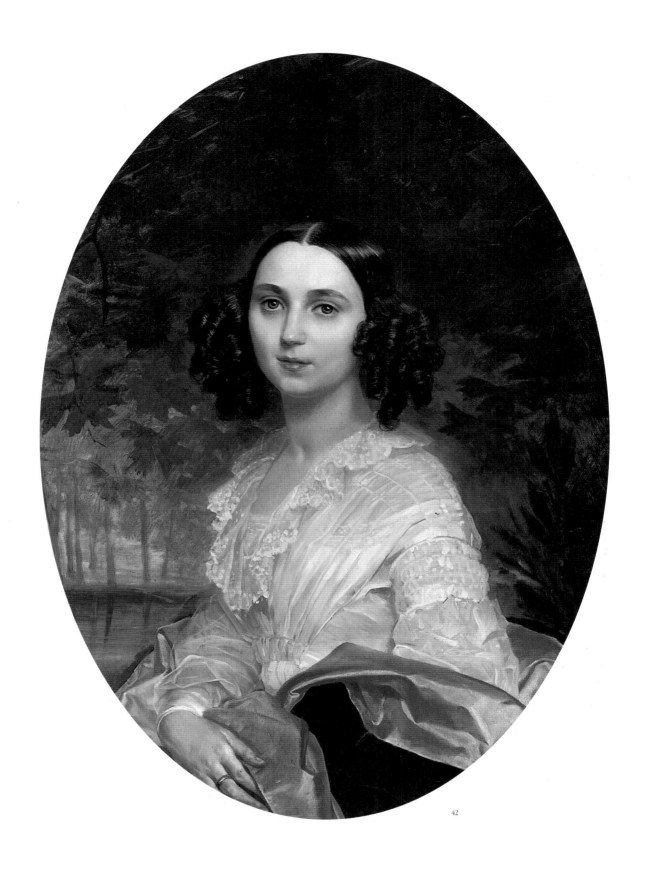

42

42. *PORTRAIT OF MARIA ALEXEYEVA*
1837–40

Oil on canvas. 92 x 73 cm
Tretyakov Gallery, Moscow

Maria Ivanovna Alexeyeva (1817–1890),
née Trofimova

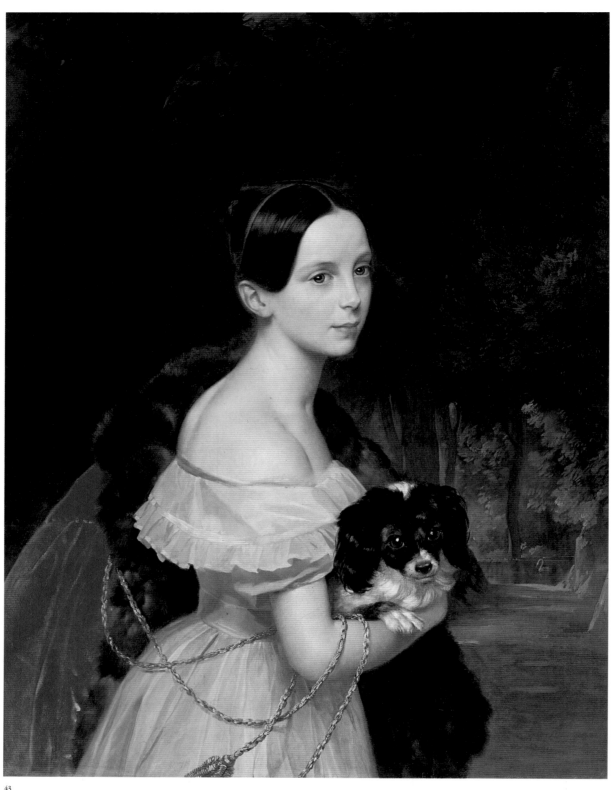

43

43. *PORTRAIT OF ULYANA SMIRNOVA*
1837–40
Oil on canvas. 90 x 71.5 cm
Russian Museum, St Petersburg
Ulyana M. Smirnova, née Spiridonova

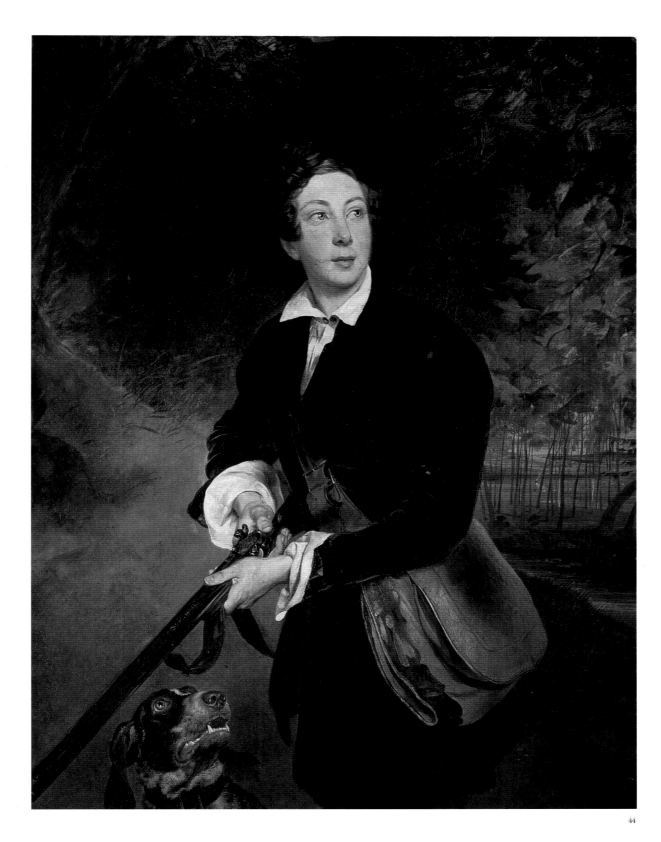

44. *PORTRAIT OF COUNT*
ALEXEI TOLSTOY
1836
Oil on canvas. 134 x 104 cm
Russian Museum, St Petersburg
Alexei Konstantinovich Tolstoy (1817–1875),
poet and playwright

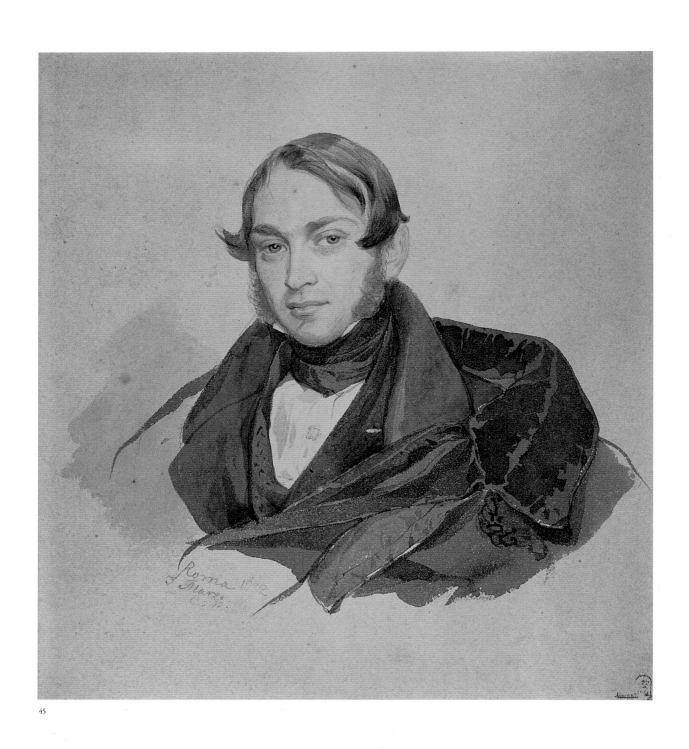

45

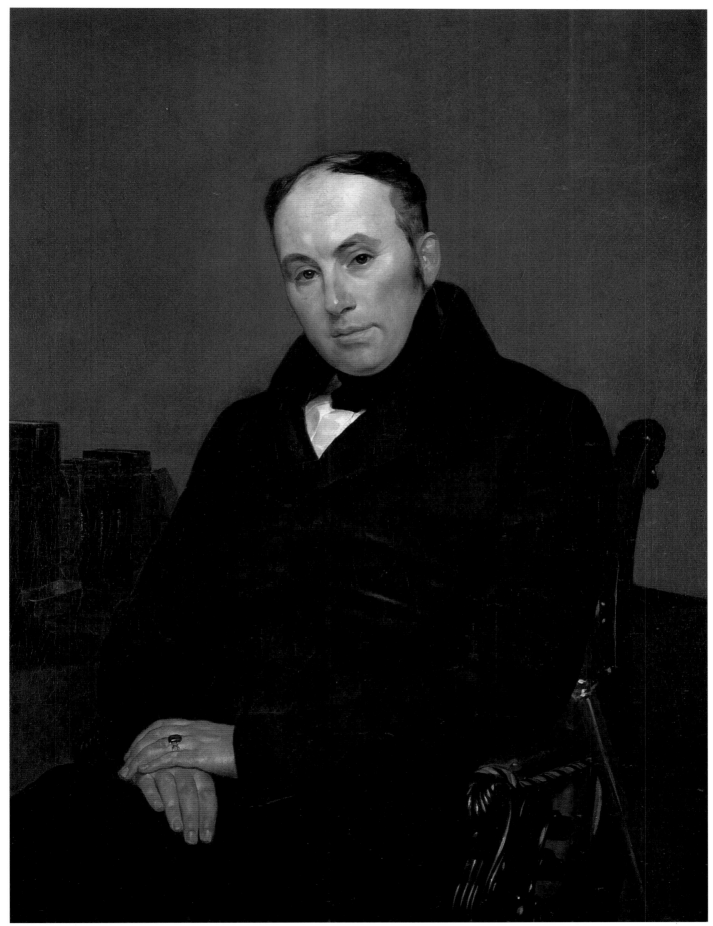

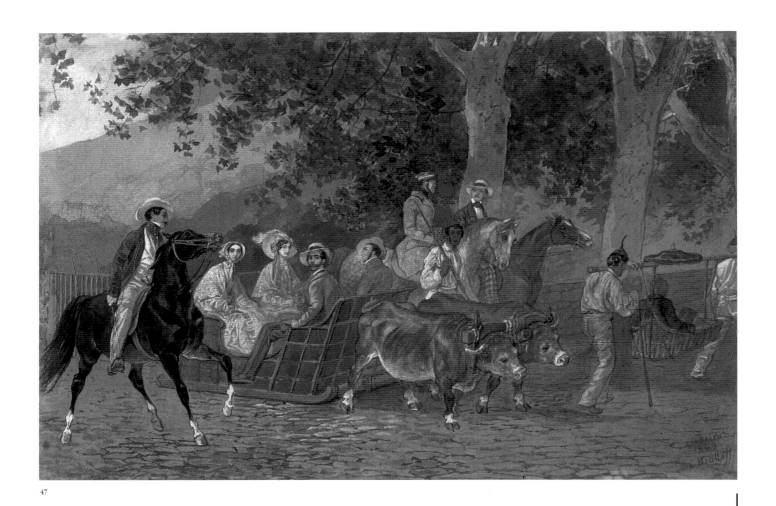

47

47. *PROMENADE (MAXIMILIAN, DUKE OF LEUCHTENBERG, EMILIA MUSSARD, YE. MUSSARD, PRINCE BAGRATION, PRINCESS A. BAGRATION, MIKHAIL ZHELEZNOV, NIKOLAI LUKASHEVICH AND KARL BRIULLOV)*
1849

Watercolour on paper. 30 x 46 cm
Tretyakov Gallery, Moscow
Maximilan, Duke of Leuchtenberg
(1817–1852), President of the Academy
of Arts (1843–52)
Mikhail Zheleznov and
Nikolai Lukashevich, painters,
pupils of Karl Briullov

48. *PORTRAIT OF THE SHISHMARIOV SISTERS, OLGA AND ALEXANDRA*
1839

Oil on canvas. 281 x 213 cm
Russian Museum, St Petersburg
Alexandra Afanasyevna Shishmariova
(?–1893), Chernyshova by her first marriage,
Durasova by her second. Olga Afanasyevna
Shishmariova, Olsufyeva by marriage

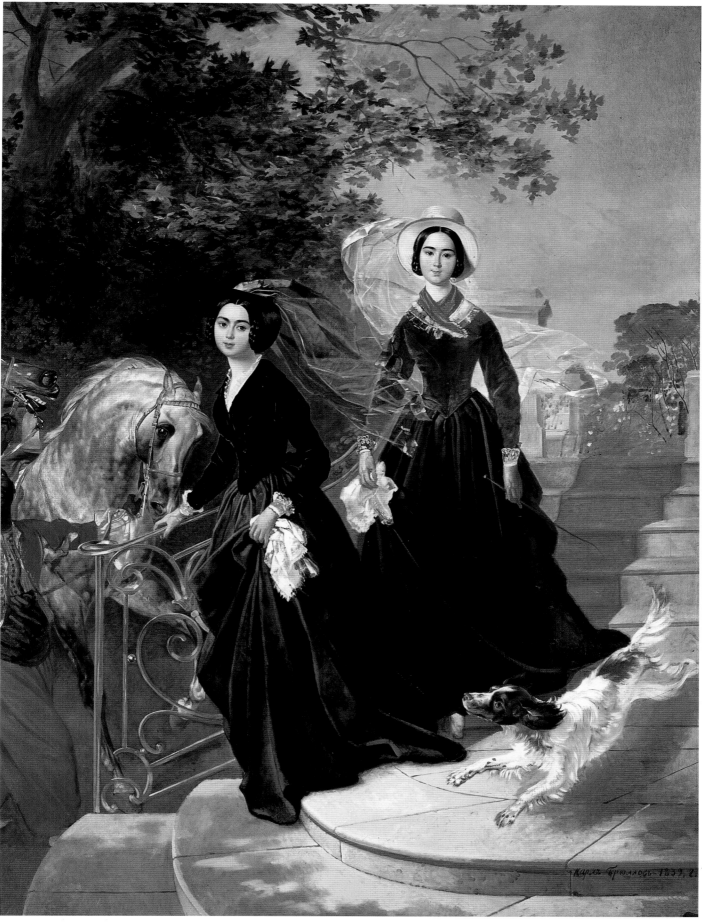

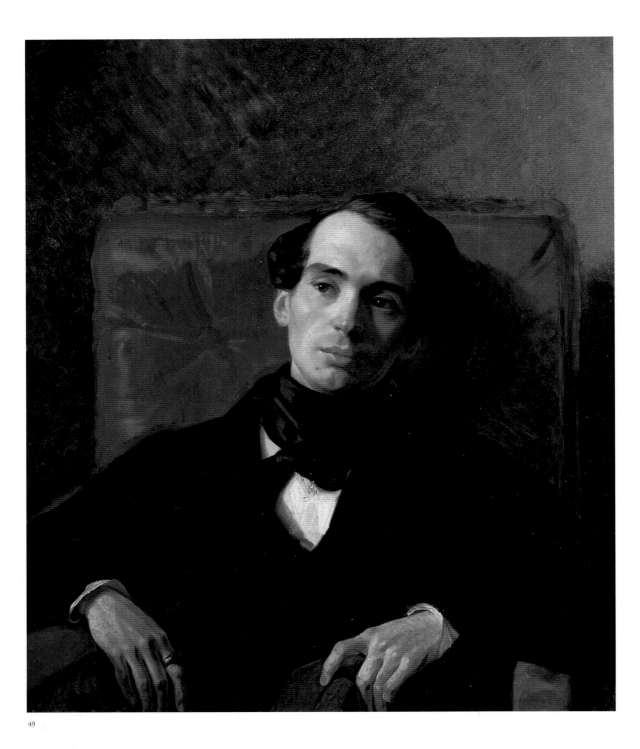

49

49. *PORTRAIT OF ALEXANDER STRUGOVSHCHIKOV*
1840

Oil on canvas. 80 x 66.4 cm
Tretyakov Gallery, Moscow
Alexander Nikolayevich Strugovshchikov
(1809–1878), writer

50. *PORTRAIT OF ALEXANDER BRIULLOV*
Not later than 1841

Oil on canvas. 123.5 x 97.5 cm
Russian Museum, St Petersburg

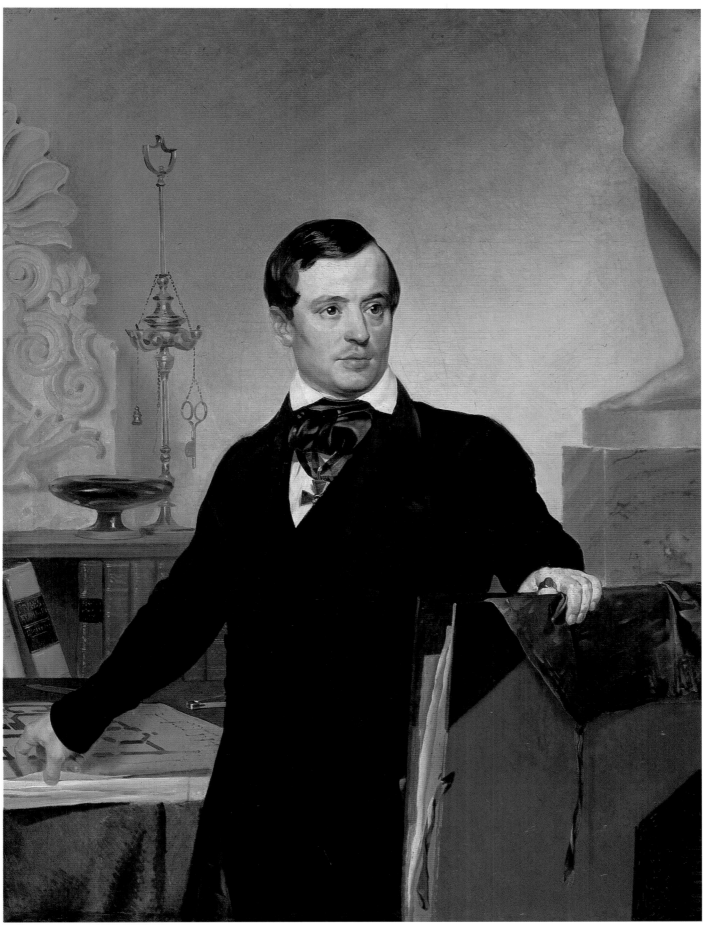

51

51. *PORTRAIT OF ANNA PETROVA*
1841
Oil on canvas. 79.5 x 67 cm
Russian Museum, St Petersburg
Anna Yakovlevna Petrova (1816–1901),
née Vorobyova, opera singer

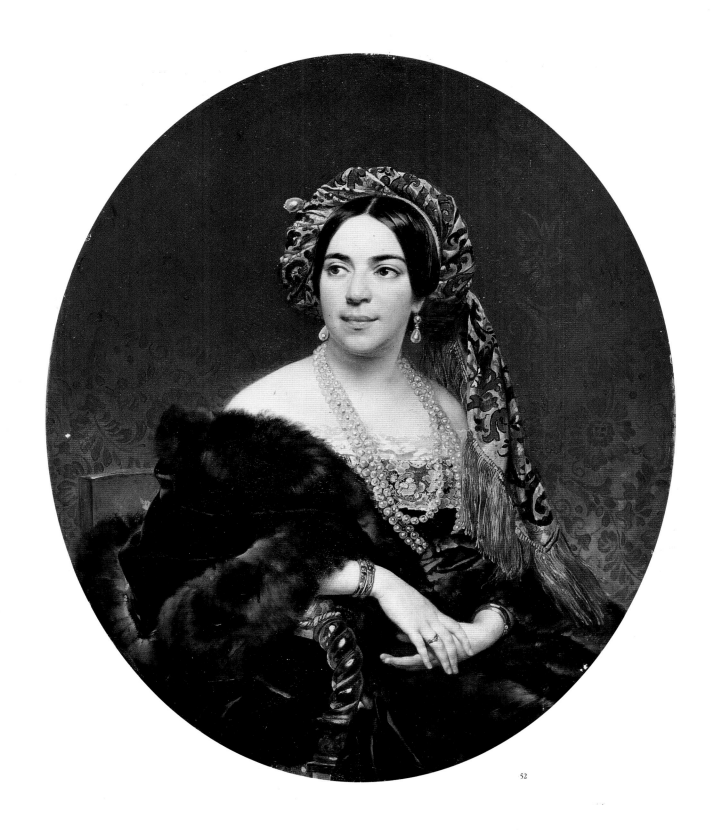

52

52. *PORTRAIT OF PRINCESS MARIA VOLKONSKAYA*
Not later than 1842

Oil on canvas. 103 x 85 cm
Russian Museum, St Petersburg
Maria Petrovna Volkonskaya (1816–1856),
née Kikina, daughter of Piotr Kikin, a founder
of the Society for the Encouragement of Artists

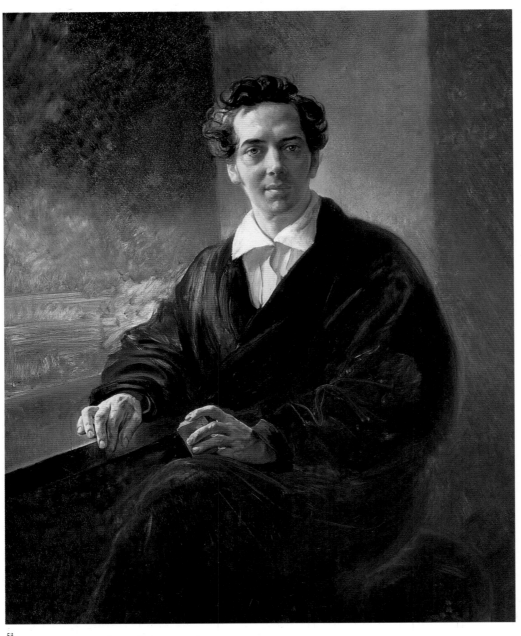

53

53. *PORTRAIT OF COUNT ALEXEI PEROVSKY*
1836

Oil on canvas. 136 x 104 cm
Russian Museum, St Petersburg

Alexei Alexeyevich Perovsky (1787–1836),
writer (under the pen-name of Antony
Pogorelsky)

54. *PORTRAIT OF MARIA BECK WITH HER DAUGHTER*
1840

Oil on canvas. 246 x 193.5 cm
Tretyakov Gallery, Moscow

Maria Arkadyevna Beck (1819–1889),
née Stolypina, wife of Ivan Beck, Princess
Viazemskaya by her second marriage

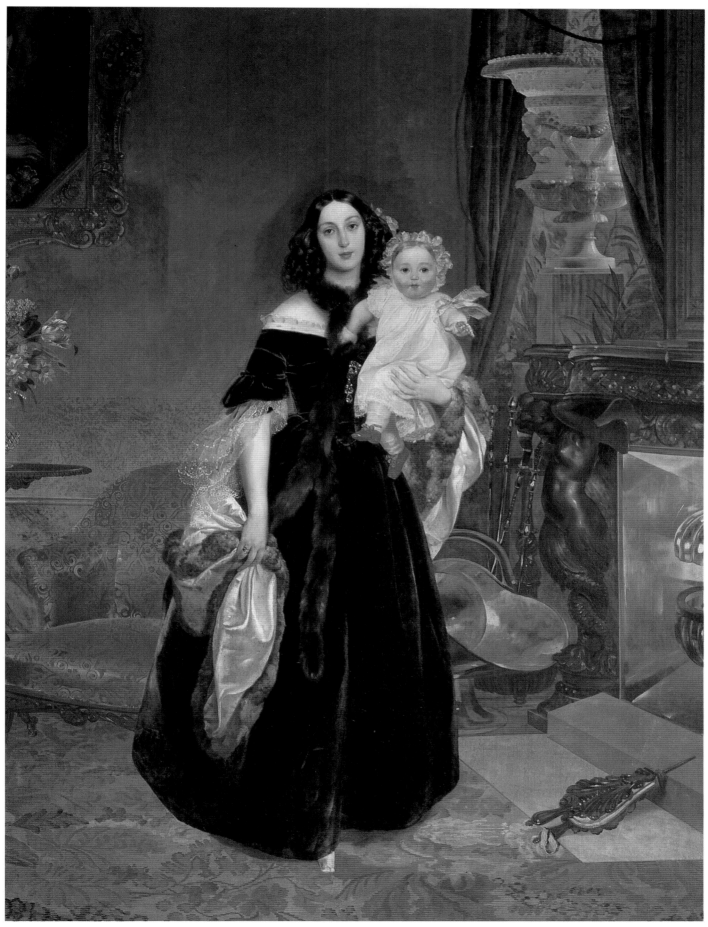

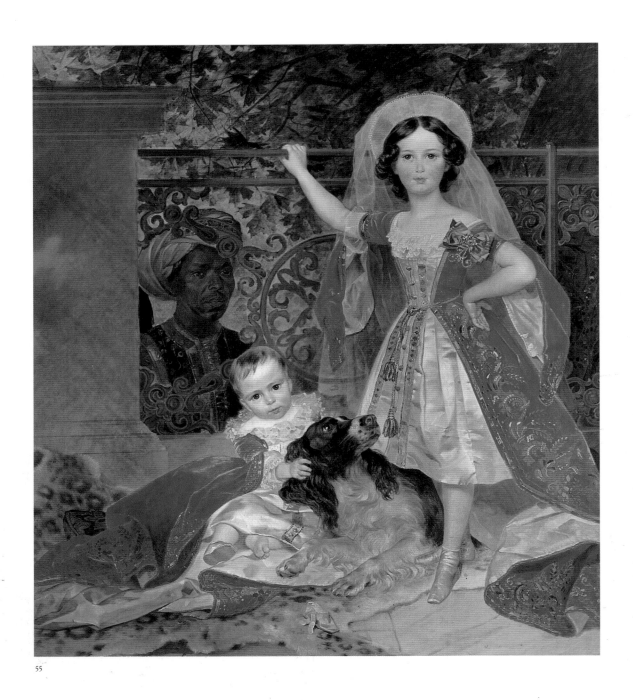

55

55. *PORTRAIT OF THE YOUNG PRINCESSES VOLKONSKY BY A MOOR*
1849

Oil on canvas. 146.1 x 224.1 cm
Tretyakov Gallery, Moscow

Princess Sophia Dmitriyevna Volkonskaya
(1841–1875), Princess Repnina by mariage,
and Princess Yelizaveta Grigoryevna
Vokonskaya (1838–1891)

56. *PORTRAIT OF PRINCESS YELIZAVETA SALTYKOVA*
1841

Oil on canvas. 200 x 142 cm
Russian Museum, St Petersburg

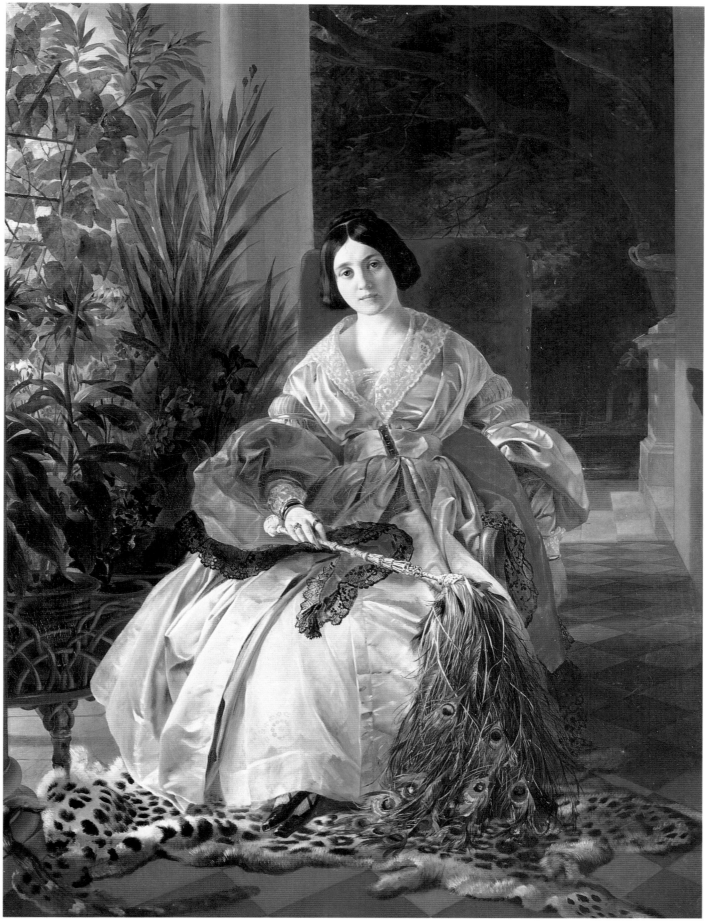

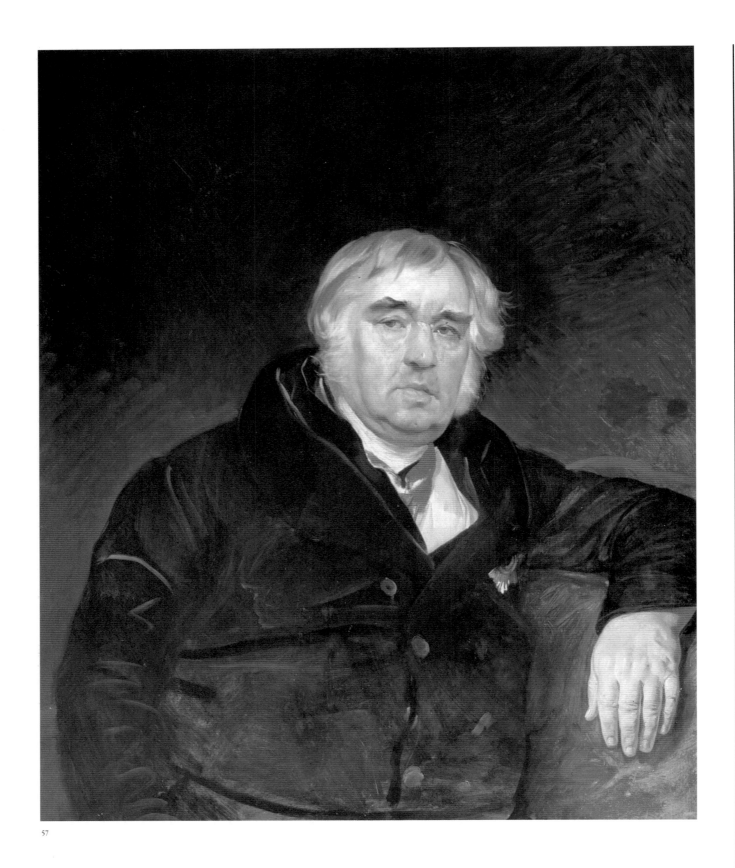

57

57. *PORTRAIT OF IVAN KRYLOV*
1839
Oil on canvas. 102.3 x 86.2 cm
Tretyakov Gallery, Moscow
Ivan Andreyevich Krylov
(1786–1844), fabulist

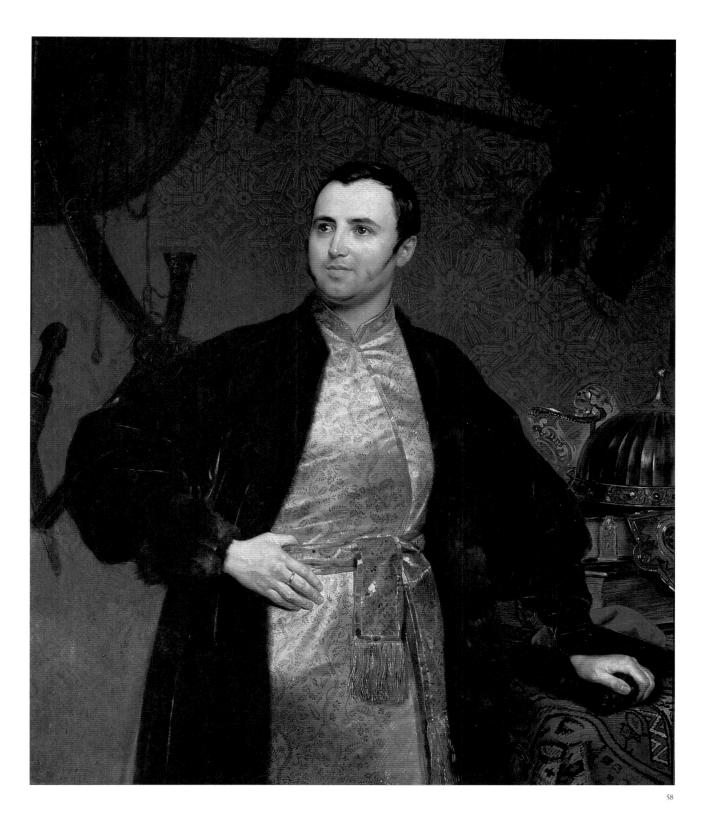

58

58. _Portrait of Prince_ _Mikhail Obolensky_
1840–46

Oil on canvas. 123.7 x 106.7 cm
Tretyakov Gallery, Moscow

Mikhail Andreyevich Obolensky
(1806–1873), archaeologist, Director
of the Central Archives of the Ministry
of Foreign Affairs in Moscow

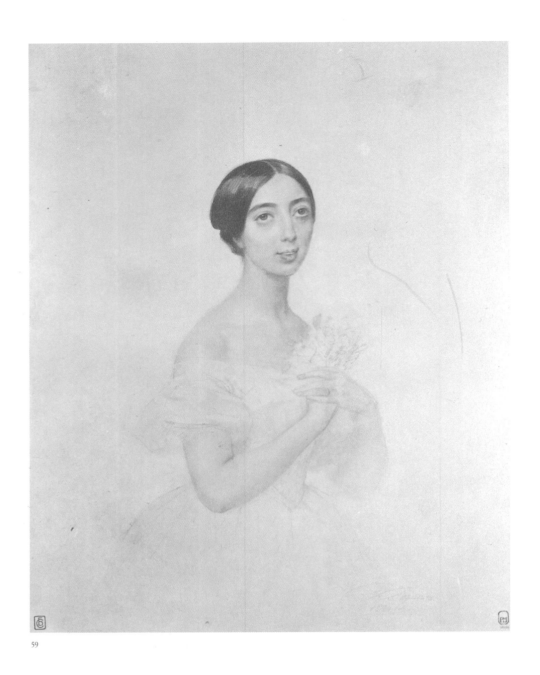

59

59. *PORTRAIT OF THE SINGER PAULINE VIARDOT-GARCIA*
1844

Lead pencil on paper. 36.2 x 27 cm
Russian Museum, St Petersburg
Pauline Viardot-Garcia (1821–1910),
Italian singer

60. *PORTRAIT OF COUNTESS YULIA SAMOILOVA WITH HER ADOPTED DAUGHTER AMAZILIA PACINI (MASQUERADE)*
Not later than 1842

Oil on canvas. 249 x 176 cm
Russian Museum, St Petersburg
Yulia Pavlovna Samoilova (1803–1875),
née Countess Palen

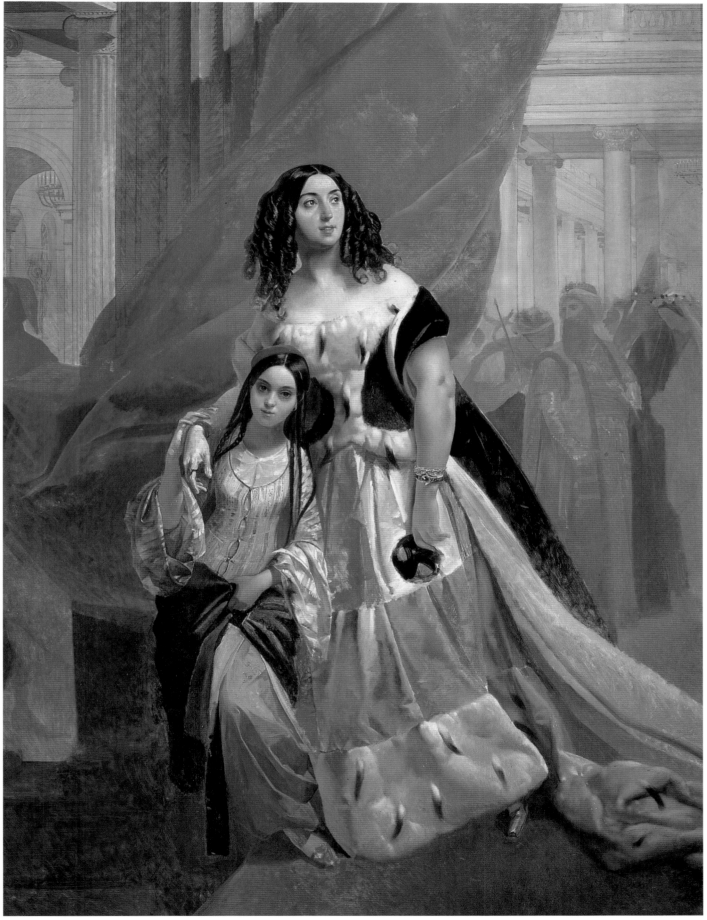

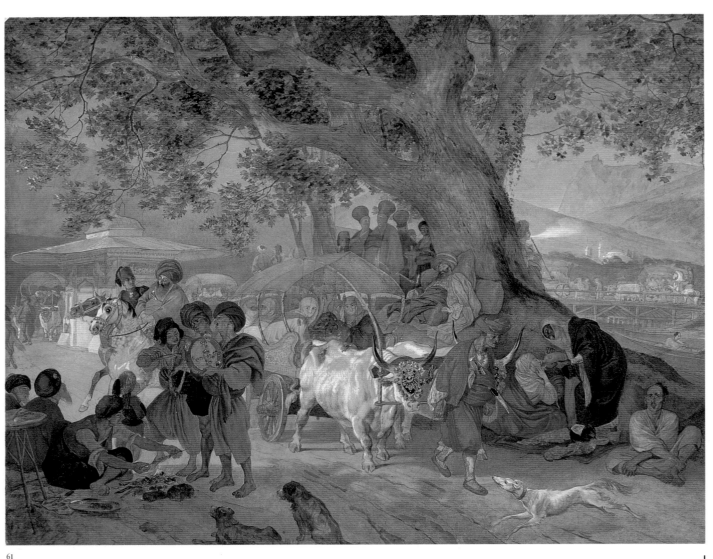

61

61. _SWEET WATERS NEAR_
CONSTANTINOPLE
1849
Watercolour on paper. 69 x 87 cm
Russian Museum, St Petersburg

62. _RIDERS (PORTRAIT OF_
YE MUSSARD AND EMILIA MUSSARD)
1849
Watercolour and black chalk,
heightened with lacquer,
on cardboard. 69 x 50.9 cm
Tretyakov Gallery, Moscow
Ye. A. Mussard (_c._ 1814–1896),
honorary member of the Academy of Arts;
Emilia Mussard (_c._ 1823–1902),
wife of Ye. Mussard

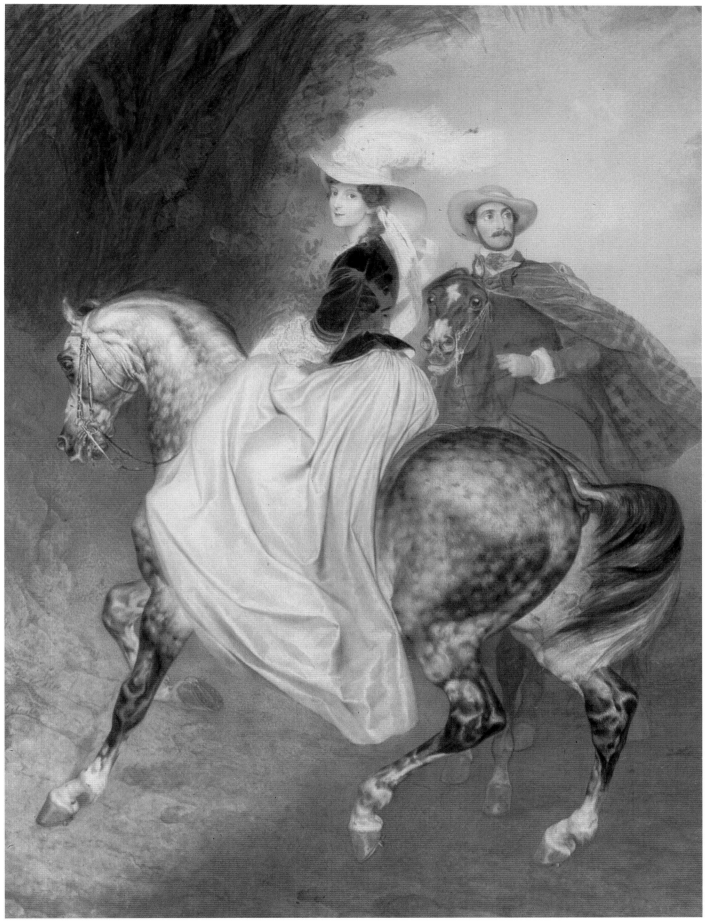

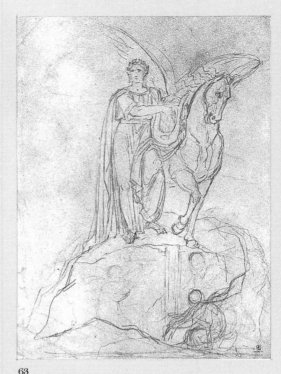

63

63. *MONUMENT*
TO ALEXANDER PUSHKIN
1837. Sketch
Lead pencil on paper. 10.6 x 6.8 cm
Russian Museum, St Petersburg

64

64. *APOLLO DRIVING HIS CHARIOT*
ACROSS THE CELESTIAL SPHERE.
THE CELESTIAL SPHERE WITH THE
PLANET OF SATURN, THE SIGNS OF
ZODIAC, GODS AND APOLLO
1846. Sketches for murals in the
Pulkovo Observatory
Pen and Indian ink and lead pencil
on paper. 20.5 x 33.5 cm
Russian Museum, St Petersburg

65

65. *THE MOOR OF PETER THE GREAT
TAKING LEAVE OF THE COUNTESS*
1847–49. Illustration for Pushkin's
novel *The Moor of Peter the Great*
Watercolour and black chalk,
heightened with bronze, on paper.
23.7 x 25.9 cm
Tretyakov Gallery, Moscow

67

66. *BY ALLAH'S WILL THE SHIRT*
IS CHANGED ONCE A YEAR
1843
Sepia on cardboard. 23 x 18 cm
(exposed area)
Russian Museum, St Petersburg

67. *A TURKISH WOMAN*
1837–39
Oil on canvas. 66.2 x 79.8 cm
Tretyakov Gallery, Moscow

68

68. *TWO LADIES ON THE BALCONY
AND A HORSEMAN*
1847–49
Based on a subject form a novel
by Alexandre Dumas
Sepia on paper. 26.5 x 23 cm
Russian Museum, St Petersburg

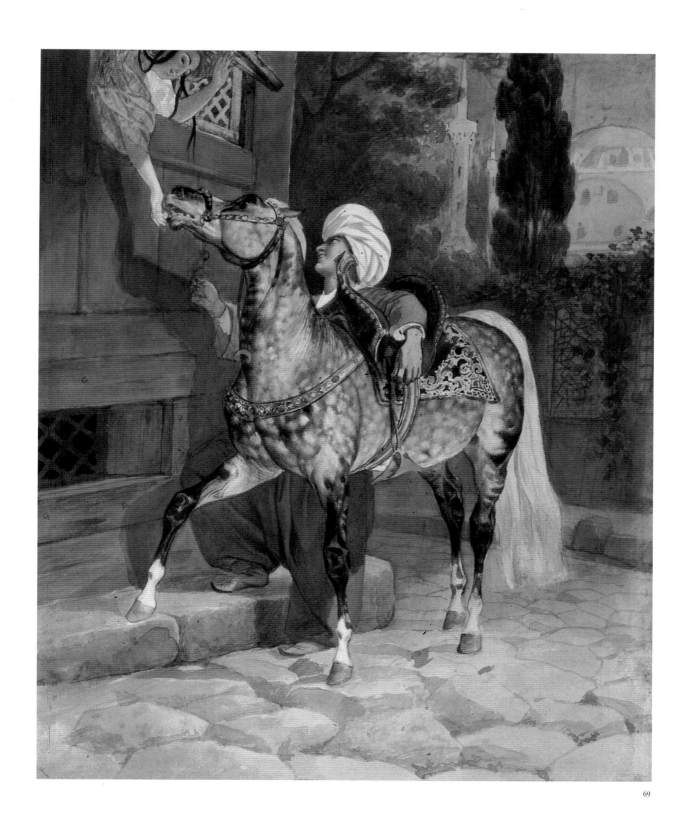

69

69. *A RENDEVOUZ*
IN CONSTANTINOPLE
1837–40
Watercolour and black chalk, heightened
with lacquer, on paper. 33.6 x 27 cm
Tretyakov Gallery, Moscow

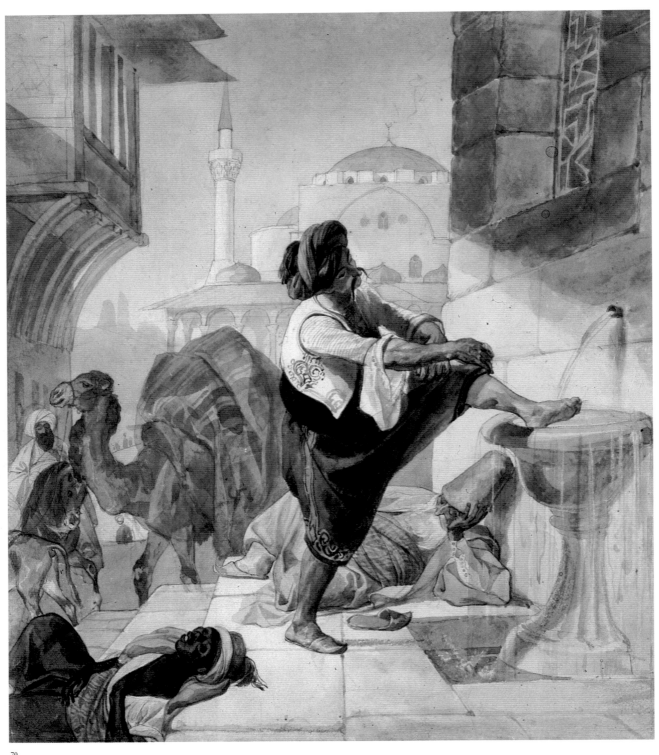

70

70. _MIDDAY IN A CARAVANSERAI_
1835
Sepia and lead pencil on paper.
32.5 x 28 cm
Tretyakov Gallery, Moscow

71. *THE DEPARTING KNIGHT*
1836

Pen and ink with brown wash
on paper. 25.2 x 18.3 cm
Tretyakov Gallery, Moscow

71

72. *LOVE SCENE IN A PARK*
1847–49. Based on a subject
from a novel by Alexandre Dumas.

Sepia on paper. 22 x 17.5 cm
Russian Museum, St Petersburg

72

73

73. *PLANETS OF SATURN AND JUPITER*
(THREE VERSIONS
OF THE COMPOSITION)
1846
Sketches for murals
in the Pulkovo Observatory
Lead pencil on paper. 20.7 x 33.3 cm
Russian Museum, St Petersburg

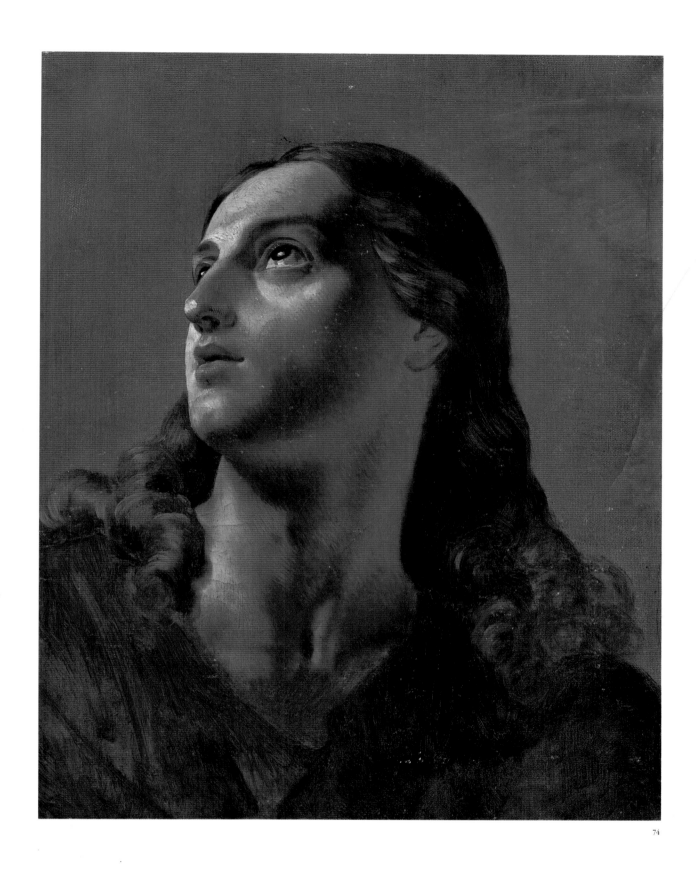

74

74. *ST JOHN THE DIVINE*
1843–47. Study for a ceiling
painting in the central dome
of St Isaac's Cathedral

Oil on canvas. 53 x 42 cm
Russian Museum, St Petersburg

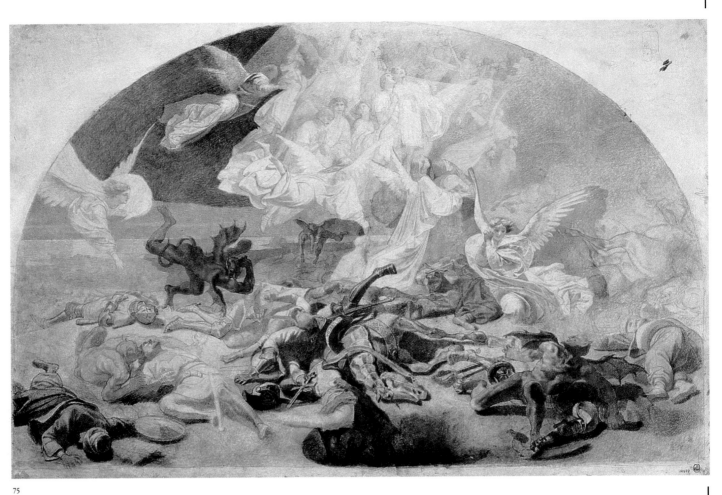

75

75. *BATTLE BETWEEN SARACENS
AND CRUSADERS*
1849
Based on a subject from Torquato
Tasso's poem *Jerusalem Delivered*
Black chalk on paper.
67.5 x 101.7 cm
Russian Museum, St Petersburg

76. *THE EVANGELIST MARK*
1843–47. Sketch for a pendentive
painting in St Isaac's Cathedral
Oil on canvas. 35 x 48 cm
Russian Museum, St Petersburg

77. *THE ASSUMPTION*
1839. Sketch
Black chalk on paper.
50.1 x 25.3 cm
Russian Museum, St Petersburg

78. *INNOCENCE LEAVING*
THE EARTH
1839
Black chalk on paper.
33.6 x 57 cm
Russian Museum, St Petersburg

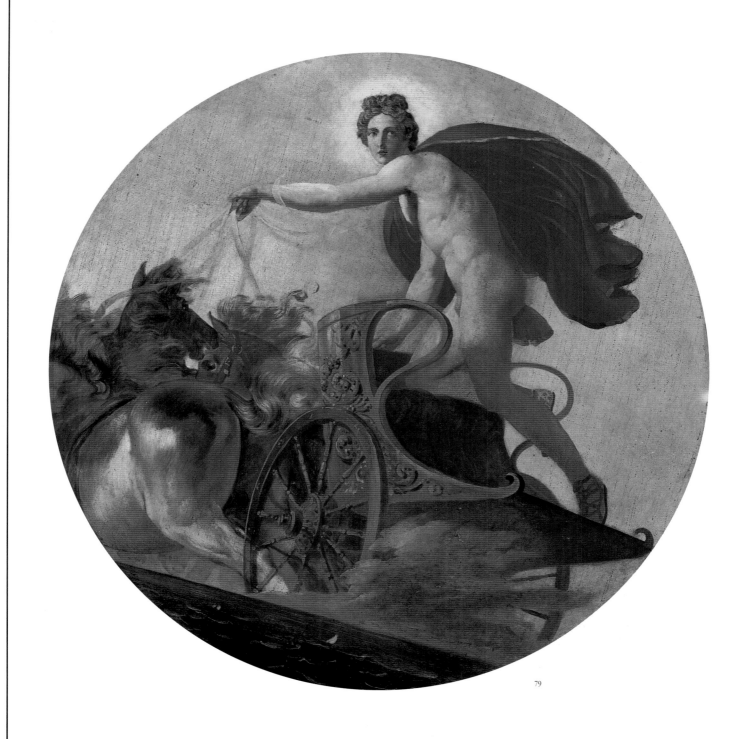

79

79. _PHOEBUS DRIVING HIS CHARIOT_
1852
Oil on canvas.
Tondo, diameter 95.5 cm
Russian Museum, St Petersburg

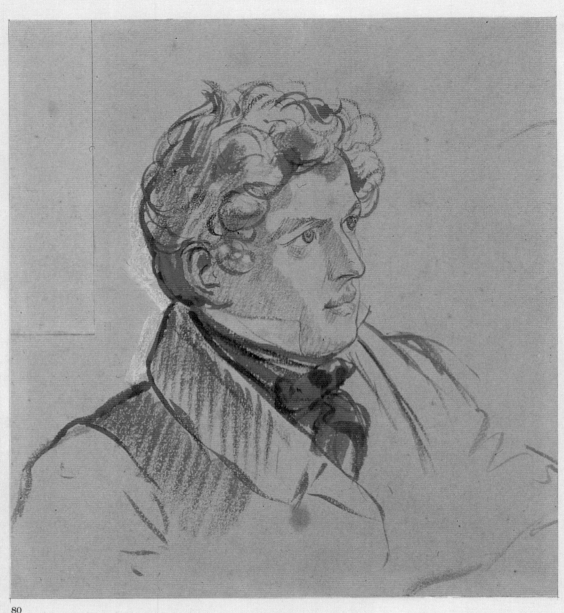

80

80. *SELF-PORTRAIT*
1833–35
Sepia on paper, heightened with white.
16.7 x 15.2 cm
Tretyakov Gallery, Moscow

1799

23 December: Born in St Petersburg.

1809

Enters the preparatory school of the St Petersburg Academy of Arts.

1813

Draws his first self-portrait.

1815

Finishes the preparatory school and enrolls in the Academy of Arts where he studies under Professor Andrei Ivanov.

1817

Receives the First Silver Medal for his study *Models*.

1818

Receives the Second Gold Medal for the composition *The Presentation of Ulysses to Nausicaä*.

1819

Receives the Second Gold Medal for his painting *Narcissus*. "Karl Briullov, a student of the Academy of Arts" is mentioned by the press.

1817–20

Drawing *The Genius of Art*.

About 1820

Portrait of Maria Kikina as a Child.

1821

Graduates from the Academy of Arts.

1821–22

Portraits of the actor Alexander Ramazanov and his wife, and of Piotr Kikin and his wife Maria.

1822

Composition *Sodom on Fire*.

16 August: Beginning of the painting study tour — Karl and his brother visit Riga, Memel, Königsberg, Berlin, Munich, Venice, Padua, Bologna, Florence and Rome.

1823

2 May: Arrival in Rome.

Self-portrait. Sketch *Prince Oleg Nailing His Shield to the Gates of Tsargrad*.

1823–35

Lives in Italy. Associates with members of the Russian colony — pensioners of the Academy of Arts, diplomats and the nobility.

Maintains friendly relations with Italian artists, composers, writers and public figures.

Visits studios of the painter Vincenzo Camuccini and the sculptor Bertel Thorvaldsen.

1824

Karl Briullov's brother Pavel dies.

Pictures *Italian Morning* and *Erminia with the Shepherds*. Portraits of the artist Sylvester Shchedrin and the architect Alexander Lvov. Sketches *Hope Nourishing Love, Daphnis and Chloe* and *Numa Pompilius and the Nymph Egeria*.

1825

His mother dies. Compositions *Piferari before the Image of the Madonna, Pilgrims* and *Vespers*.

1826

Portrait of his brother, the architect Alexander Briullov.

1827

Meets Countess Yulia Samoilova.

Paints *Italian Midday*, Sketch *Hylas and Nymphs* and others. Double portraits of Kirill and Maria Naryshkin and of Grigory and Varvara Olenin.

July: First trip to Naples and Pompeii. Meets Anatoly Demidov, member of a family that owns metallurgical works in the Urals, a patron of art, who commissions *The Last Day of Pompeii*. Conceives the painting and does his first sketch for it.

1827–28

Portraits of the artists Fiodor Bruni and Nikolai Okhotnikov.

1828

Portrait of the musician and composer Matvei Vielgorsky.

Portrait of the athlete Domenico Marini (*Ball Player*). Study *Vaulter*.

Finishes the copy of Raphael's *School of Athens*. The painter Camuccini considers it the best copy of Raphael. Stendhal admires it in his *Promenades dans Rome*. The Russian Embassy pays Briullov 10,000 roubles for this copy.

1829

Resigns his membership in the Society for the Encouragement of Artists.

Portrait of Prince Grigory Gagarin.

1830

Portrait of Princess Zinaida Volkonskaya. Formal portrait of Grand Duchess Yelena Pavlovna with her daughter. Sketch *Kuzma Minin Rescuing Russia*.

Having produced a number of preliminary sketches and studies, starts work on *The Last Day of Pompeii*.

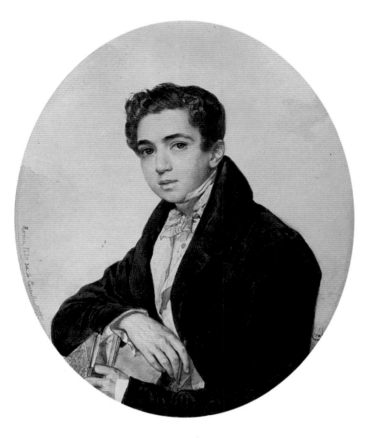

About 1831

A trip to Bologna and Venice.

1831

Sketches for the portrait of Anatoly Demidov. The second trip to Naples. Meets the composer Mikhail Glinka.

1832

Paints *Rider*. Finishes the picture *Bathsheba*. Portrait of Sergei Sobolevsky, man of letters and bibliographer.

About 1833

Portrait of Prince P. Lopukhin.

1833

Completes the composition *The Last Day of Pompeii*. His father dies.

1833–34

Portrait of the Italian sculptor Cincinnato Baruzzi.

1834

Goes to Paris where *The Last Day of Pompeii* is displayed in the Louvre. The Salon jury awards him the First Gold Medal.

His brother Ivan dies.

Completes *Portrait of Yulia Samoilova with Her Adopted Daughter Giovanina Pacini and an Ethiopian Boy*, begun in 1832. Painting *The Death of Inés de Castro*. Portraits of the singers Fanni Persiani-Tachinardi and Giuditta Pasta (as *Anne Boleyn*), the Italian barrister Francesco Ascani, the Italian artist Ignazio Fumagalli,

the architect Alexei Gornostayev, the banker Marietti's family, Countess Olga Orlova with her daughter Natalia. Paints his self-portrait for the Uffizi Gallery.

1833–35

Portraits of Count Carlo Pozzo di Borgo and of Archbishop Giuseppe Capecelatro of Taranto, an active participant in the Risorgimento movement.

Works on a composition showing Baroness Yekaterina Meller-Zakomelskaya with her daughter and the artist in a boat.

Sketch *Genseric's Invasion of Rome*.

Self-portrait. Portraits of Anna Schwarz and Princess Yelizaveta Saltykova.

1835

Portraits of the poet Vasily Zhukovsky, and of Countess Olga Fersen riding a donkey. Sketch of a composition *The Murder of Prince Andrew of Hungary by Order of Giovanna of Naples*. Scene *An Italian Woman Lighting a Lamp before the Image of the Madonna*.

May 16: The beginning of Demydov's expedition. In Athens, Briullov is taken seriously ill. He interrupts his voyage and transfers to the brig *Themistocles* bound for Constantinople via Smyrna.

Works produced during the expedition: *A Greek Morning at Miraka*, *The Ruins of the Temple of Jupiter at Olympia*, *The Temple of Apollo Epikourios at Phigalia*, *The Ithome Valley before a Thunderstorm* and others. Portrait of Vladimir Kornilov on board the brig *Themistocles*. It is probably on the *Themistocles* that Briullov does his illustrations in lead pencil intended for transference to lithographs: *The School of Homer*, *Morning in the Valley of Phigalia*, *The Temple of Jupiter at Nemea* and others.

Works produced in Constantinople: *Portrait of Alexander Kostenich*, *Midday in a Caravanserai*, *Harbour in Constantinople* and some other scenes of daily life in Constantinople.

Portrait of Maria Buteneva, the wife of the Russian envoy in Turkey, with her daughter Maria.

1835

Late autumn: Sails for Odessa where he is received in state by the citizens.

25 December: Arrives in Moscow.

28 December: The artistic circles of Moscow give a dinner in honour of Briullov. Strikes up a friendship with the best Moscow portraitist Vasily Tropinin, who begins to paint a portrait of Briullov. Makes friends with the sculptor Ivan Vitali, the painters Yegor Makovsky and the Dobrovolsky brothers, the former Decembrists Count Musin-Pushkin and Count Mikhail Orlov, and the Moscow Governor-General Prince

Karl Briullov
< *PORTRAIT OF PRINCE GRIGORY GAGARIN*
1829
Watercolour on paper.
19.8 x 16.5 cm
Russian Museum, St Petersburg

Maxim Vorobyov
VIEW OF THE MOSCOW KREMLIN FROM THE STONE BRIDGE
1818

Dmitry Golitsyn. A strong patriot, Golitsyn commissions Briullov to create a painting devoted to Moscow in 1812. The painter's conception was never realized, although Briullov produced a number of sketches on the subject of *Napoleon Leaving Moscow Set on Fire and Abandoned by the Citizens*. Makes the acquaintance of the celebrated actor Mikhail Shchepkin.

1836–49

In the course of this period associates with many representatives of Russian culture. Frequents Matvei Vielgorsky's house, which was considered the centre of musical life in St Petersburg. The master of the house, a high official, was himself a talented composer and pianist. Visits the salons of Fiodor Tolstoy, Vice-President of the Academy of Arts, and of the writer Vladimir Sollogub. Often goes to the parties arranged by Prince Vladimir Odoyevsky, a novelist, philosopher and historian, one of the first music theorists in Russia; and by Yekaterina Karamzina, the widow of the historian Nikolai Karamzin and the poet Piotr Viazemsky's sister. Visits the salon of the writer Ivan Panayev among whose guests were the actors Yakov Briansky and Vasily Samoilov, the singer Osip Petrov, the composers Mikhail Glinka and Alexander Varlamov, the literary critic Vissarion Belinsky, and the writer Fiodor Dostoyevsky.

An ardent theatre-goer, Briullov attends all new drama performances and operas. He maintains friendly relations with St Petersburg actors, the Samoilovs (father and son) and the Karatygin brothers. Frequents the concert-hall of the Pavlovsk railway station near St Petersburg (where the famous *Fantasy Waltz* by Glinka was performed for the first time). Never misses performances of outstanding European singers and musicians touring Russia, such as Giovanni-Battista Rubini, Antonio Tamburini, Pauline Viardot, Robert Schumann, Franz Liszt and Clara Wieck.

1836

Portraits of the poet Yevgeny Baratynsky, the actress Yekaterina Semionova, the writer Count Alexei Perovsky (Anthony Pogorelsky) and his nephew Count Alexei Tolstoy who subsequently became known as an outstanding Russian poet and playwright, the artist Ivan Durnov and his wife Yelizaveta Durnova, the artist Yegor Makovsky, and a portrait of Ivan Vitali. Composition *Svetlana Divining before a Mirror* and illustrations for Anthony Pogorelsky's novel *The Convent Girl*. Konstantin Basili's book *Bosporus and New Essays on Constantinople* with Briullov's drawings is published in St Petersburg.

4 May: Meets Alexander Pushkin.

18 May: Leaves for St Petersburg. Settles in Tahl's house on Nevsky Prospekt near Palace Square.

Late May – early June: Meets the writer Nikolai Gogol and draws his portrait.

11 June: Celebration at the Academy of Arts in honour of Briullov's arrival.

June: Is granted an audience in the Winter Palace.

25 June: Leaves for Pskov.

On his return from Pskov moves into a new apartment in the building of the Academy of Arts.

Begins work on a sketch for the painting *The Siege of Pskov*. Makes the acquaintance of the poet Nestor Kukolnik. Another meeting with Glinka.

Portraits of Nestor Kukolnik and of Briullov's sister Yulia, now married to the famous watercolourist Piotr Sokolov.

24 September: Is appointed Professor of the Second Degree. According to the memoirs of the writer Dmitry Grigorovich, the son of the Conference-Secretary of

the Academy, "all the 'academists', young and old, were burning with the desire to become Briullov's pupils."

1836–37

Portrait of the sculptor Ivan Vitali.

Meets Alexei Venetsianov. Helps Taras Shevchenko, a poet and artist, to obtain his freedom from serfdom.

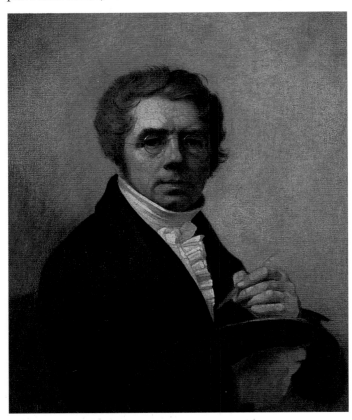

1837

Sketch *Mercury Expelling Venus*.

Sketches of a frontispiece for Alexander Pushkin's collected works. Draft design for a monument to Pushkin.

Nicholas I commissions Briullov to paint his portrait. The artist evades fulfilling the commission (only a crossed-out sketch of the Tsar's survives).

Portrait of Count Vasily Perovsky. Begins work on a portrait of Empress Alexandra Fiodorovna with the Grand Duchesses. Delays the fulfilment of the commission, which will never be completed.

1837–38

Portraits of Vasily Zhukovsky, Princess Yelizaveta Saltykova, Princess Aurora Demidova, Count V. Musin-Pushkin, the Austrian envoy Count Karl Ludwig von Ficquelmont and his daughter Eliza.

About 1839

Meets Emilia Timm and marries her, but the marriage is dissolved after two months.

Arrival of Countess Yulia Samoilova from abroad. Paints *Masquerade*, depicting Samoilova with her adopted daughter Amazilia Pacini.

1839

Portrait of the fabulist Ivan Krylov. Portraits of the sisters Alexandra and Olga Shishmariov, Baroness Yuliania Klodt, the sculptor Piotr Klodt's wife, and Ivan Beck.

Composition *Innocence Leaving the Earth*. Begins working on the canvas *The Siege of Pskov*.

1837–40

Portraits of Yelena Thon, the architect Konstantin Thon's wife; Professor of Vilno (Vilnius) University Platon Kukolnik, brother of the writer Nestor Kukolnik; Princess Maria Volkonskaya, née Kikina; Maria Alexeyeva and Ulyana Smirnova.

Does much work as a caricaturist.

1840

Portraits of the poet and translator Alexander Strugov-shchikov, the architect Ippolit Monighetti, Maria Beck with her daughter, and Prince Alexander Golitsyn.

About 1841

Portrait of the architect Alexander Briullov, the artist's brother.

1841

Portraits of the artist Yakov Yanenko (in armour), Professor of the Medical Academy Karl Yanish, and the singer Anna Vorobyova.

Pavel Fedotov, subsequently a famous Russian artist, joins Briullov's class.

1842–43

Meets the literary critic Vissarion Belinsky.

Meetings between the "brotherhood" (Glinka, Briullov and Kukolnik) and the famous composer and pianist Franz Liszt, who visited St Petersburg twice. A few years later Liszt will call Briullov a genius.

Abandons work on *The Siege of Pskov*.

1844

Portrait of the singer Pauline Viardot-Garcia, done during her tour in Russia.

The "brotherhood" breaks up.

1843–47

Works on the murals for the new St Isaac's Cathedral.

1845

Completes his sketches for the wall paintings in St Isaac's Cathedral and starts work on the murals themselves.

About 1846

Portrait of Countess Sophia Shuvalova.

Alexei Venetsianov
< *SELF-PORTRAIT*
1811

Maxim Vorobyev
*ST ISAAC'S CATHEDRAL AND
THE MONUMENT TO NICHOLAS I*
1844

1846

Produces sketches of compositions for the murals in the Pulkovo Observatory, *Planets of Saturn and Jupiter* and *Apollo Driving His Chariot across the Celestial Sphere*.

1847

October: Briullov falls seriously ill. The painting of the interior of St Isaac's Cathedral after Briullov's sketches is entrusted to Piotr Basin.

1848

Self-portrait. Portrait of Konstantin Kavelin, philosopher and lawyer, an eminent Russian thinker and public figure of the 1840s.

The second meeting with Gogol, which proved to be the last.

Late 1848 – early 1849

The last meeting with Glinka.

1849

Composition *Sweet Waters near Constantinople*. Portraits of Fiodor Prianishnikov, Postmaster General and art collector, Doctor G. Kanzler, Doctor M. Markus and his daughter, and Countess Sophia Bobrinskaya. *27 April:* Goes abroad for treatment. Travels to Cologne via Warsaw, then moves on to Brussels and London. From England he goes to Portugal. In Lisbon, Briullov paints a portrait of the Russian envoy Sergei Lomonosov. Settles in Funchal, the main city on the island of Madeira. Portrait of Princess Anna Bagration. Composition *Promenade*. Portrait of Ye. and Emilia Mussard (*The Riders*). *View of the Island of Madeira*.

1850

Portrait of A. Abaza. In early summer leaves Madeira for Spain, then moves on to Italy.

Strikes up a friendship with Angelo Tittoni, a prominent figure in the Risorgimento movement and an active participant in the Revolution of 1848. Stays in the house of Tittoni's family in Rome.

Sketches of the composition *Political Demonstration in Rome in 1846* and of the painting *The Return of Pope Pius IX to Rome from the Basilica of Santa Maria Maggiore*. Portrait of the diplomat P. Stroganov. *Head of an Abbot. The Procession of the Blind in Barcelona*. Portrait of the archaeologist Michelangelo Lanci.

1851

Portraits of Angelo Tittoni, his mother Catarina and his daughter Giulietta.

1851–52

Portraits of Angelo Tittoni's brothers: Vincenzo, Antonio and Mariano. Portrait of Mariano's wife with her children.

A series of sepias *Lazzaroni on the Seashore*. Portrait of Anatoly Demidov. Painting *Girl in a Forest*.

1852

Sketches *Solar Eclipse, Cemetery of Monte Testaccio, All-Destroying Time*.

23 June: Dies in Manziana, at the country-house of the Tittoni family. Buried in the cemetery of Monte Testaccio.

К: Брюлловъ.